The Museum of Mysteries

Front cover: Henri Rousseau, *The Dream,* see pp. 172–173

© 2014 Olo Éditions, Paris
© for the English edition: Prestel Verlag, Munich · London · New York, 2014

German and English translation rights are arranged with Olo Éditions
through Manuela Kerkhoff – International Licensing Agency

Credits on page 176

Library of Congress Control Number: 2013956173;
British Library Cataloguing-in-Publication Data: a catalogue record for this book is available from the British Library;
Deutsche Nationalbibliothek holds a record of this publication in the Deutsche Nationalbibliografie;
detailed bibliographical data can be found under: http://www.dnb.de

Prestel books are available worldwide. Please contact your nearest bookseller or one of the above addresses
for information concerning your local distributor.

Prestel Verlag, Munich
A member of Verlagsgruppe Random House GmbH

Prestel Verlag
Neumarkter Strasse 28
81673 Munich
Tel. +49 (0)89 4136-0
Fax +49 (0)89 4136-2335

Prestel Publishing Ltd.
14–17 Wells Street
London W1T 3PD
Tel. +44 (0)20 7323-5004
Fax +44 (0)20 7636-8004

Prestel Publishing
900 Broadway, Suite 603
New York, NY 10003
Tel. +1 (212) 995-2720
Fax +1 (212) 995-2733

www.prestel.com

Authors: Éléa Baucheron and Diane Routex
Editorial direction of the French edition: Nicolas Marçais
Artistic direction: Philippe Marchand
Editorial support: Énaïde Xetuor-Docin
Layout: Prestel Verlag, based on the design by Marion Alfano
Thanks to: Thierry Freiberg for his attentive look

Editorial direction: Claudia Stäuble, Dorothea Bethke
Translation from French: Fabia Claris
Copyediting: Chris Murray
Cover: Stefan Schmid Design, Stuttgart
Typesetting: textum GmbH, Munich
Production: Astrid Wedemeyer
Printing and Binding: Tien Wah Press, Singapoure

Verlagsgruppe Random House FSC® N001967
Printed on FSC®-certified paper *Titan MA*
produced by Hansol Paper Co., Korea

ISBN 978-3-7913-4920-6

Éléa Baucheron
Diane Routex

The Museum of Mysteries

ART'S BEST-KEPT SECRETS

Are there any works of art that do not have some mystery about them? Critics and art historians are forever trying to bring such secrets to light, like detectives investigating a perplexing case. But their task is never done because the scope of their enquiry shifts with every new development: new lines of enquiry emerge, new points of view come to the fore, and whole new areas of investigation are identified. There is something powerful about any form of representation and this is one of the aspects of art that lend it its abiding mystery and appeal. In many cultures, it has a magical or religious power, and can also have a political or social force; having the power to speak without words, art can show, please, teach, inspire, or offend. Works of art are seldom anodyne and almost always complex, requiring careful study and research to elucidate their messages and aims, which are often not entirely clear and are sometimes deeply puzzling.

Some works of art are instantly compelling and defy us not to engage with them precisely because we have been conditioned to think of them as mysterious (see *The Mona Lisa*, page 54, or the Pyramids of Egypt, page 88); because they seem abstruse, made up of symbols which cry out to be deciphered (see *Melencolia 1*, page 150, or *The Caress,* page 166); or because they belong to a culture or context to which we no longer hold the key (see the drawings in

the cave at Lascaux, page 128, or the Easter Island *moai*, page 12). There are others that are the complete opposite, works which we think we know, with which we are over-familiar or which we think of as immediately comprehensible, but which in fact contain secrets we do not suspect. Some artists play on the public's curiosity by producing works that deliberately leave viewers questioning and so arouse their interest, making the artist more widely known in the process. Artists like Banksy, who studiously maintains his anonymity (page 80), and Marcel Duchamp, who contrived to keep his posthumous work secret until the grave (page 32), are keenly aware of the effect such publicity stunts can have in boosting their fame.

Art speaks to everyone in different ways and historians, connoisseurs and ordinary members of the public will all respond to it in their own unique way, bringing their specific knowledge and experience to bear on what they see, going on their impressions or relying on their feelings. There is no single right way to approach or appreciate art. Theories breed counter-theories, misguided notions are discredited, all fuelling vociferous debate that may or may not get us anywhere nearer the truth. This book does not pretend to resolve all the mysteries it explores. We have to accept that we will never exhaust the possible meaning of a work of art: in the last analysis, we must learn to embrace its mystery.

CONTENTS

DESTINY

IDENTITY

CREATION

MEANING

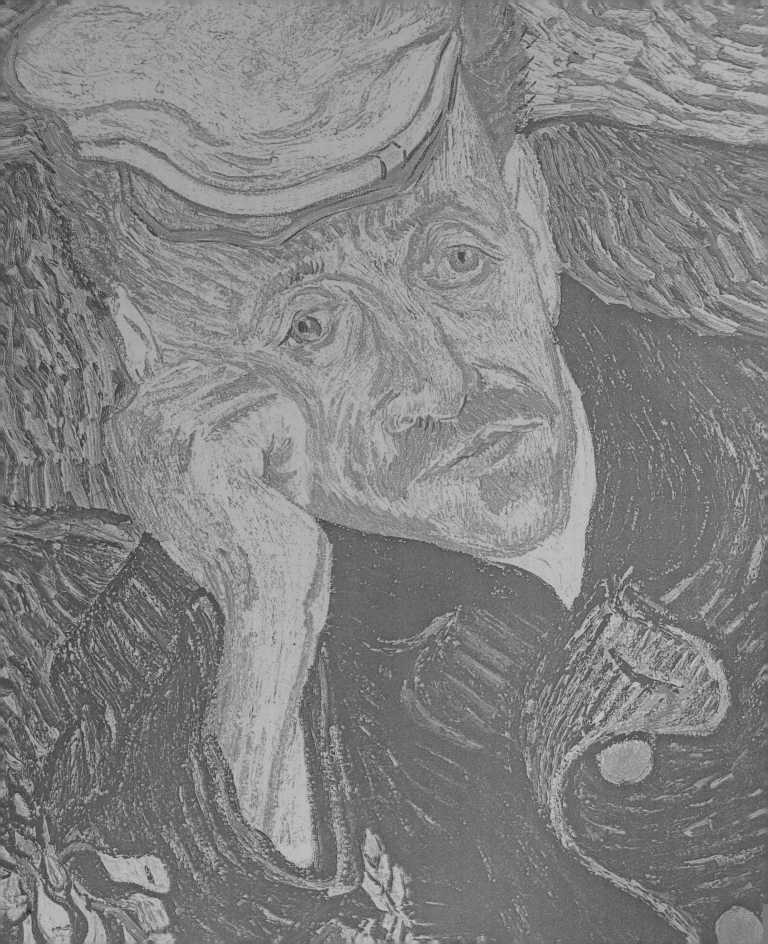

DESTINY

The life of a work of art can often be eventful, surprising, even dramatic. Whether they have been around for 100, 500, or 2,000 years, they tend to have seen many things in their time. If only they could speak, their stories would astonish.

The Easter Island *moai* (page 12) could explain the mystery of how they came into being, *The Battle of Anghiari* by Rubens (page 16) might allow us to locate Leonardo da Vinci's lost fresco of the same name, and *The Portrait of Doctor Gachet* (page 28) in the Musêe d'Orsay in Paris could tell us once and for all whether or not it was painted by Vincent van Gogh. There are many cases like that of the Leonardo da Vinci fresco, where the very existence of a work of art can be in doubt, often because they have mysteriously disappeared and we know them only through copies or from descriptions. Sometimes uncertainties over attribution leave masterpieces unrecognized and neglected.

Art works can also come to grievous ends. Many prize pieces of our cultural heritage have been and will continue to be destroyed in the course of wars, fires and other disasters. Sometimes the destruction is deliberate, as was the case in the Second World War with the countless paintings reduced to ash by the Nazis because they were seen as "degenerate art,"

but also as recently as 2001, when the two giant Buddhas of Bamiyan in Afghanistan, which were deemed "anti-Islamic," were blown up by the Taliban. The fate of an art work is not in its control; it's dependent on the tide of history and the vagaries of human beings, who have an uncanny power not only to create but also to destroy.

Their fate can also depend on the capriciousness of critical history. Take *The Mona Lisa*, for example (page 54). Would she be so well known if art historians and critics had not been so desperate to discover more and more mystery in her? Another key factor can be how artists themselves present their work. If Michael Heizer had not projected such a tantalizing vision of his completed *City* (page 38), it's very likely we would have been considerably less interested in his vast land-art project (which has not yet been completed and opened to the public).

And it's not just the mysterious fate of artworks that we find intriguing, but also the turbulent lives of some of their makers and even some of the people depicted in them. Was Caravaggio really assassinated on a beach, or did he die of fever (page 24)? And what of Gabrielle d'Estrées, who appears naked in an anonymous sixteenth-century painting (page 20)? Did she die in childbirth, or was she poisoned by sinister forces at court? If only works of art could speak…

THE MYSTERY OF THE STONE GIANTS

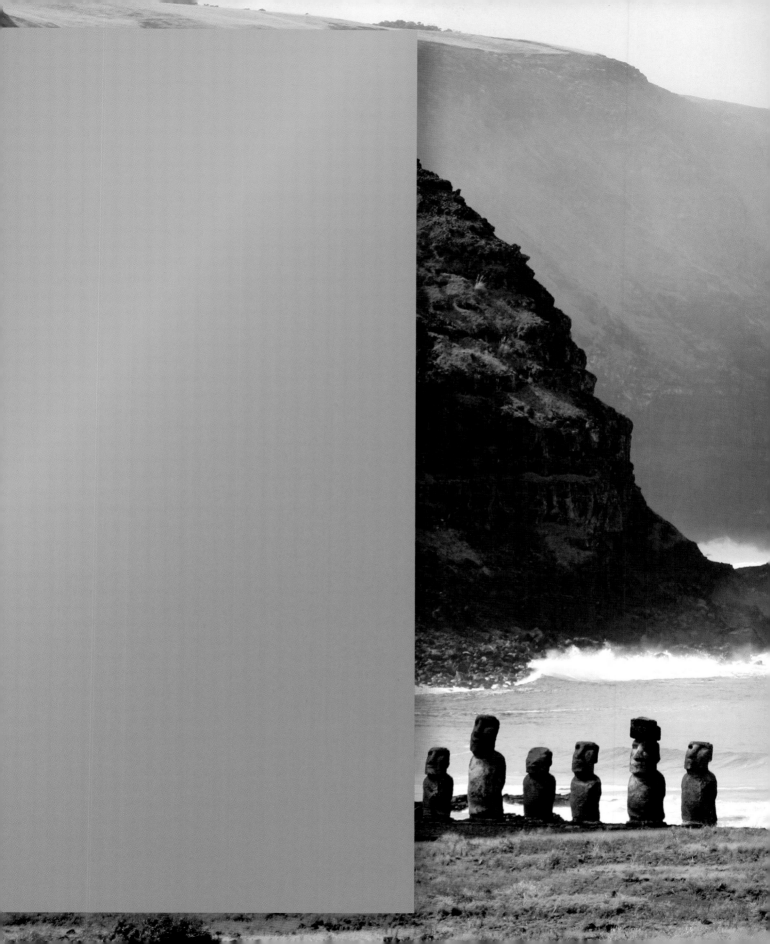

Little is known about the people who lived on Easter Island, or Rapa Nui as it is called in the language of the same name, or about the *moai* that dot their land. Why the Easter Islanders devoted so much time and effort to setting up these giant stone figures remains an intriguing mystery. The island is one of the most remote places in the world and seems cursed: its people dwindled away over the centuries, leaving us only a few tantalizing clues as to the nature of their civilization.

People often think that ecological destruction and internecine wars are modern inventions, but they were tragic features of life long before our time in the tiny 163-square-kilometer world of Easter Island. It was they that destroyed the island's prosperous tribes: a combination of intensive working of the land and woods and endless fires sparked by local wars destabilized the environment, reducing the population to famine. When the Europeans arrived in the eighteenth century, they found a civilization that was already considerably diminished. Exposure to the Western world finished it off: over the course of the nineteenth century, the population of Easter Island was decimated by a tragic mixture of diseases unknown until then and introduced to the island from outside, battles in which stone weapons were met with firearms, and finally slavery.

This is why the culture of the Easter Islanders is, and is bound to remain, such a mystery to us. The most astonishing of their practices was undoubtedly their setting up of huge spectacular stone men, a practice which continued from about AD 1000 to 1650. We know that the tribes had access only to limited technology. Despite this, over 886 *moai* were recorded in 1993, each with an average height of 6 meters and weighing several tons. Every one of these monoliths had to be hewn from a quarry in a crater, then laboriously transported along barely passable tracks before finally being set in position. Local legend has it that the colossal figures walked to their appointed site once they were finished. One is almost tempted to believe it.

Archeologists, meanwhile, have focused on possible means that might have been used to move and position the figures, and have had some success with their experiments. Using ropes and a sled made of tree trunks, they have demonstrated that twenty people working together could haul and set up the colossal figures. They have also shown that rollers and levers could have been used to equal effect. Only a well-structured, organized and highly motivated culture could have carried out this work. So just what motivated these tribes?

The meaning of the *moai* is not wholly clear. They are thought to represent illustrious ancestors set up to watch over family tombs. Interestingly, the Easter Islanders have never stopped outsiders going near them, which would suggest that the *moai* do not have the sacred or taboo quality usually associated with deities. A researcher in the twentieth century observed that most of the *moai* were broken or had been thrown to the ground. It was the indigenous people who had committed these acts of destruction, most likely in the course of some inter-tribal war. Clearly they were already losing their traditions before the arrival of the Europeans, and those traditions seem doomed now to be lost forever.

Moai, c. 1000–1650,
Rapa Nui National Park, Easter Island, Chile

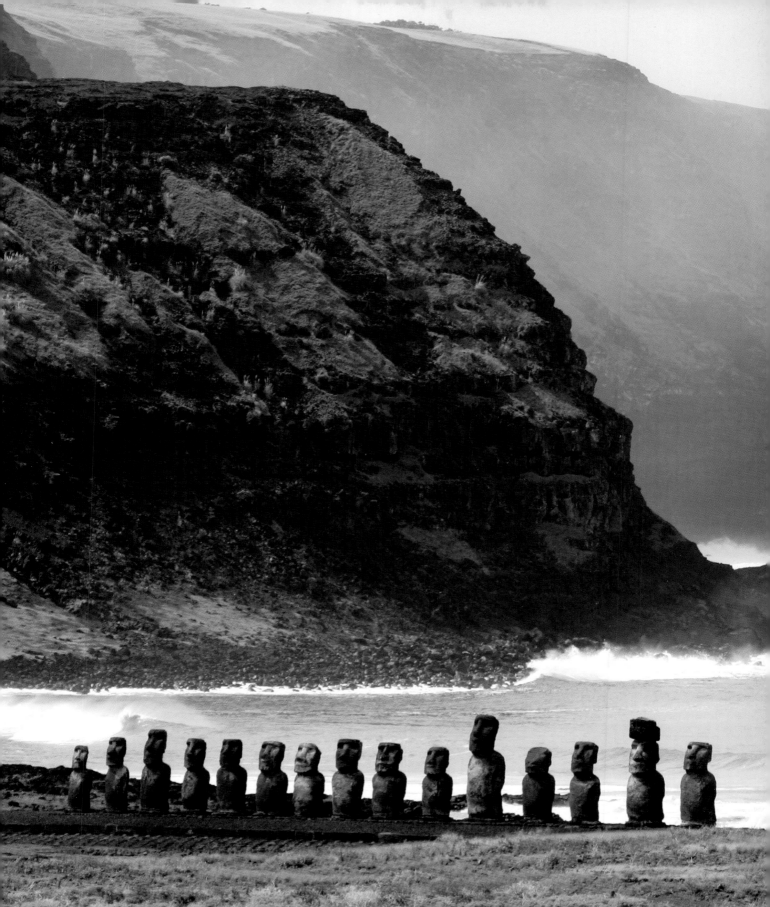

BEHIND A WALL OF SILENCE

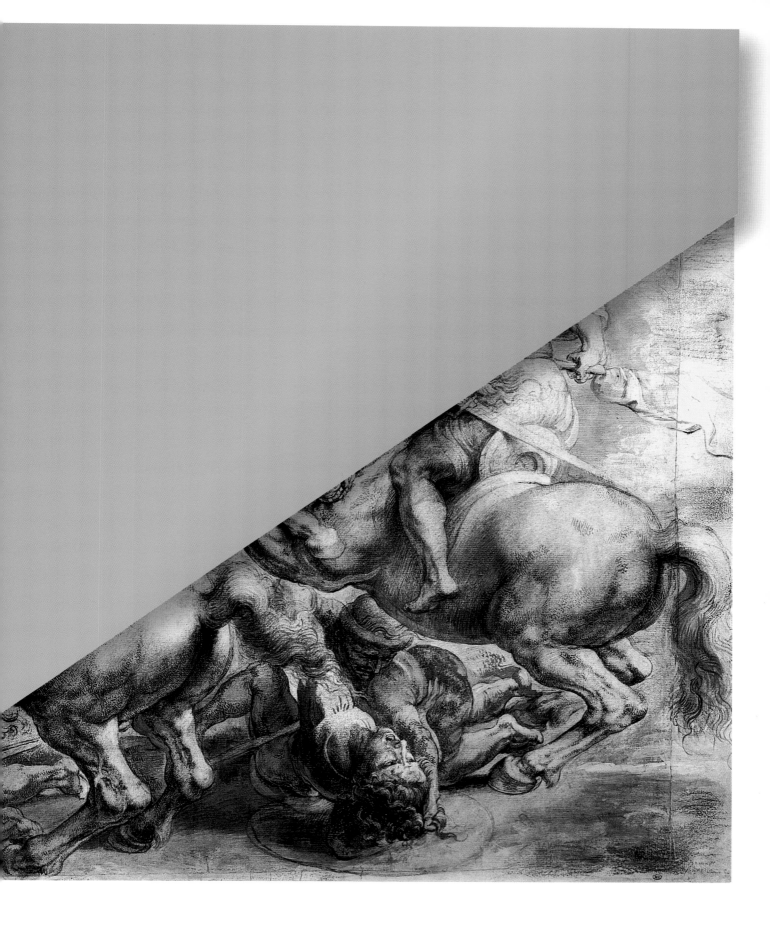

If there is a painter who really fires the imagination of the public, it's surely that incredible master of all trades, the prodigious artist and inventor Leonardo da Vinci. Even in his own lifetime he and his works in art and science were surrounded by mystery and intrigue—and still are, attracting the keen attention of those searching for hidden meanings and lost works. One painting that has contributed to da Vinci's legendary aura is *The Battle of Anghiari,* unseen since the sixteenth century, but perhaps rediscovered.

Can it be acceptable to damage a fresco by Giorgio Vasari in order to retrieve an apparently lost work by Leonardo da Vinci? This is a question that has divided commentators ever since the 1970s, when Maurizio Seracini, of the University of California in San Diego, took up the theory put forward by Carlo Pedretti in his book *The Battle of Anghiari*. According to these two commentators, this painting, which is known to us only through preparatory drawings and a copy by Rubens (opposite), was not destroyed but painted over.

How is that possibly? We need to go back to the sixteenth century to understand what happened to this lost fresco.

Leonardo is known to have worked on a fresco in the Salone de Cinquecento in the Palazzo Vecchio in Florence from 1504 to 1506. The story goes that it was a technical disaster. The great genius of the Renaissance had apparently tried a new mixture of oil paint that did not dry properly and ran. It was a time when Leonardo was distinctly pessimistic and wanted to illustrate human cruelty and savagery, a desire that seems to have brought him nothing but bad luck. He himself recorded in his notebooks that as he applied his very first stroke, at the thirteenth hour of the day, the church clock struck and all his materials went flying. Discouraged no doubt by the disasters that seemed to dog the painting process, he went to Milan leaving the work unfinished. The city of Florence tried in vain to get reimbursed.

Over half a century later, in 1563, the Medici commissioned Vasari to produce a painting of the Battle of Marciano on the same wall. The initial battle scene thus seems to have disappeared under another masterpiece. But Vasari was a great admirer of da Vinci and experts believe that he would have done everything in his power to preserve the fresco. In support of this, they point to the fact that several years later he managed to preserve a painting by Masaccio in the Church of Santa Maria Novella in Florence by building a protective brick wall in front of it.

Maurizio Seracini is firmly of this school and in late 2011 obtained permission to drill six minute holes in Vasari's work into which he inserted micro-cameras and endoscopic probes. His investigations revealed the presence under the fresco of brown and black pigments apparently of the same type as those used by da Vinci. But his exploratory tests did not offer conclusive proof and many art historians and conservators objected vigorously to the procedure and to the damage it caused to the fresco by Vasari. The tests had to be stopped as a result, leaving the question of the survival of *The Battle of Anghiari* tantalizingly unresolved.

PETER PAUL RUBENS (1577–1640),
After Leonardo da Vinci (1452–1516), **The Battle of Anghiari,** also known as **The Struggle for the Standard,** 1504–1505,
copy after drawings by Leonardo da Vinci, black chalk, pen, brown and gray ink, gray wash, heightened with white and color, 45.3 × 63.6 cm,
Musée du Louvre, Paris, France

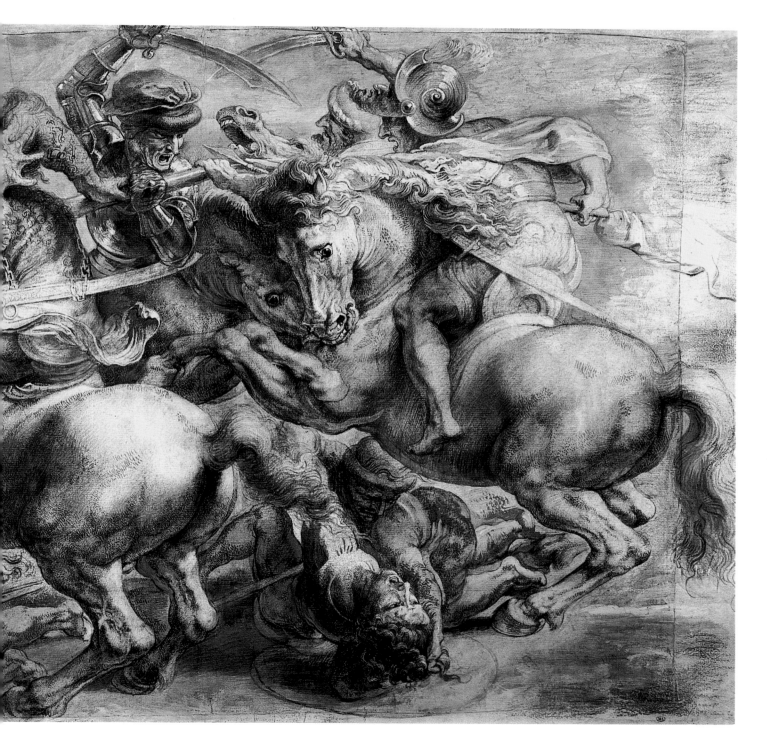

*Presumed Portrait of Gabrielle d'Estrées
and Her Sister, the Duchess of Villars*

POLITICS AND GABRIELLE'S BREASTS

Two naked women are sitting in a bath doing something strange. This may be an erotic picture, but that is not all it is: it had a symbolic role and there is far more to the two sisters than first meets the eye. The picture was aimed at King Henri IV and has a story to tell, for those able to decipher it, about a particular episode in the history of France. The allusions and hidden signs appeal to the viewer's wit and culture and make it more of an intellectual work than a lascivious one.

On the right of the picture is Gabrielle d'Estrées, Henri IV's mistress; on the left, a woman who is almost certainly her sister, the Duchess of Villars, is shown pinching Gabrielle's nipple. This strange gesture is generally interpreted as indicating that Gabrielle is pregnant by her royal lover; in the background, a servant is sewing what could well be a layette for the baby. In the foreground, the ring prominently on display could be a reminder of a promise of marriage made by the king.

What can have been the point of a picture like this, which makes such a play of the relationship between Henri IV and his mistress? To answer this we have to look more closely at Gabrielle d'Estrées and her fairytale romance with the king. Henri met her when he was nearly forty and she was only eighteen, and was immediately captivated by her extraordinary beauty. Though Gabrielle did not immediately yield to his desires, she eventually became his mistress and remained so until her death in 1599, when she was still only twenty-six. She bore him three children, including a boy in 1594. It was this child that she was expecting when this picture was painted.

Confident of the king's love, and empowered by having provided him with an heir, Gabrielle set about trying to supplant the famous Queen Margot, Marguerite de Navarre, who, unlike her, had not managed to bear Henri IV a child. The ambitious mistress had a tough battle on her hands, however: it was not easy to make a king divorce.

The picture was almost certainly designed to remind the king of his mistress's finest assets, which included not only being young and attractive but also having produced a male heir. The king was renowned as a womanizer, and nicknamed the "Green Gallant" as a result, and the sensuality of the scene must surely have been calculated to sway him. Whether or not there was a deliberately erotic intention behind the picture, let alone a suggestion of a lesbian encounter, is quite another matter.

ANONYMOUS, SCHOOL OF FONTAINEBLEAU (LATE 16TH CENTURY),
Presumed Portrait of Gabrielle d'Estrées and Her Sister, the Duchess of Villars, c. 1594,
oil on wood, 96 × 125 cm, Musée du Louvre, Paris, France

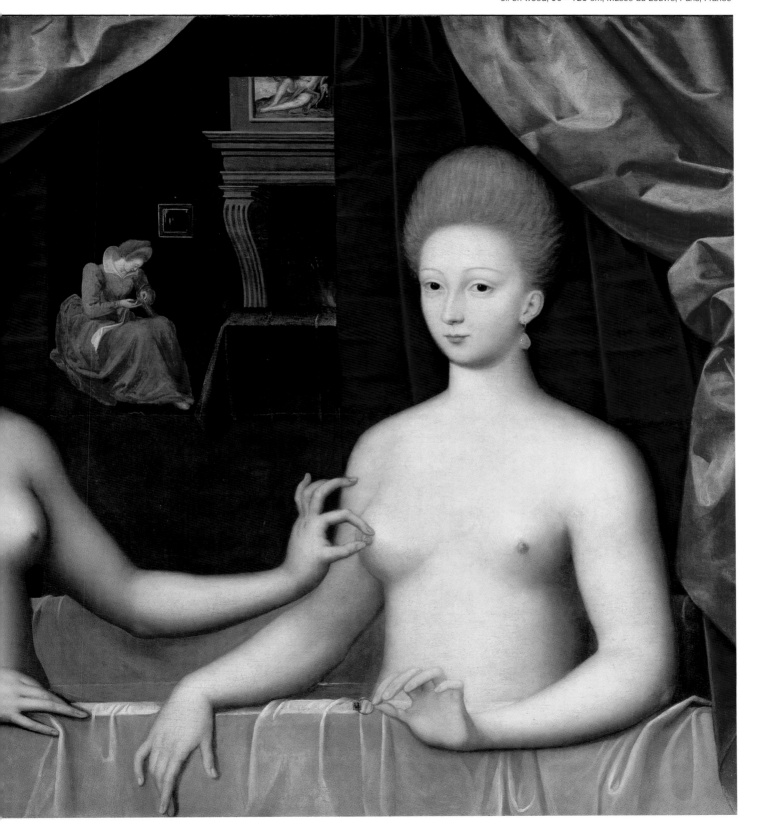

THE
SEARCH
FOR
A BODY

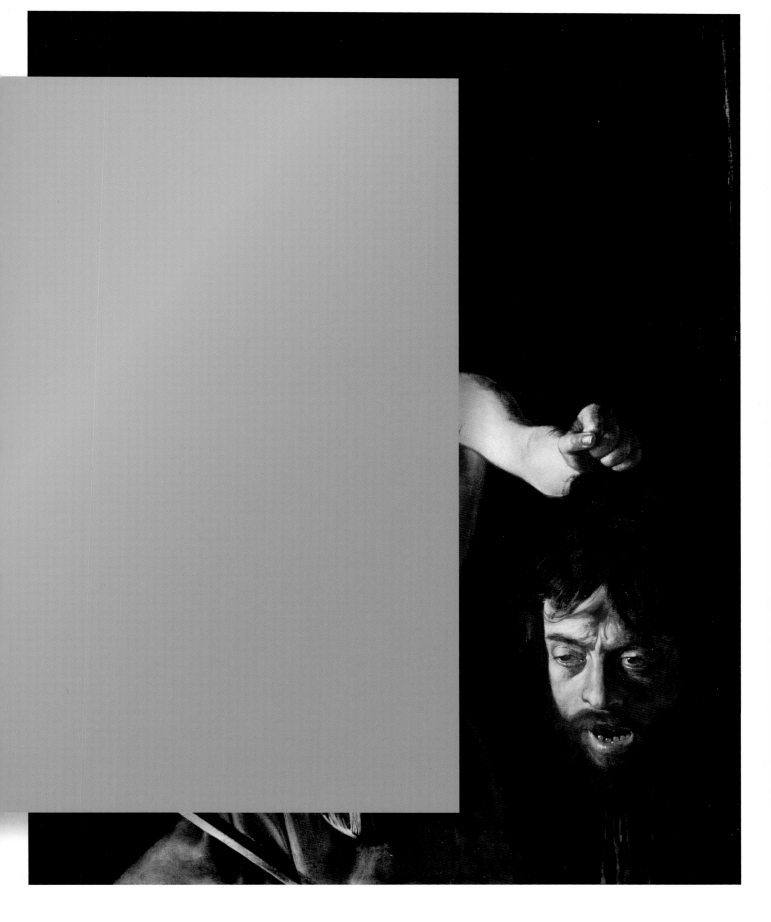

Even in his lifetime Caravaggio was a well-known and celebrated painter. As a consequence, a great deal of information has come down to us about his life. Just how he died, however, remains obscure: Was it as a result of a fever or an injury, or was he assassinated by one of his enemies?

The year 2010 marked the quarter-centenary of Caravaggio's death. Gripped by acute "Caravaggiomania," the art world celebrated the occasion impressively, using it to present new findings not only about how Caravaggio lived but also about how he died. To understand why Caravaggio's death is so intriguing, it's important to appreciate just what a turbulent life he led. Born in Lombardy in 1571, Caravaggio took himself off to Rome when he was still an adolescent. There he found highly placed patrons who "launched" his career and he soon began to receive official commissions and become better known. He was at the height of his fame when tragedy struck in May 1606. Following an argument after a game of real tennis, a man called Ranuccio Tomassoni was killed. His assailant, Caravaggio, fled from Rome. Six years of wandering followed. Banished and sentenced to death *in absentia* by the papal court, he had no choice but to be on the run. He moved from Naples to Sicily, then back to Naples again. He settled for a while in Malta but was imprisoned there for insulting an aristocrat. He managed to escape in 1608 and sailed for Sicily, where he wandered from place to place before going back to Naples, only to be seriously injured in an attack. Tired and hoping to secure a pardon from Pope Paul V, Caravaggio decided to return to Rome. He set off, armed with a clutch of paintings as "gifts" for his pardon. On disembarking at Palo, not far from his final destination, he was arrested, either because he was recognized, or, as some claim, because he was mistaken for another wanted man. He was released, but the ship had meanwhile sailed off without him, but with his paintings still in the hold. Caravaggio tried to catch up with it overland, but died on 18 July 1610, perhaps (as once widely believed) on the beach at Porto Ercole. How did he die? Was it from a fever or badly healed wounds? Was he assassinated? History does not relate, and his body has never been found. Or has it?

In 2001 a researcher found Caravaggio's death certificate. It was a revelation: Caravaggio did not die on a beach, apparently, but in hospital, and was then buried in San Sebastiano cemetery. After carrying out research based on this document, Professor Gruppioni announced in 2010 that he had found Caravaggio's remains. The bodies in the cemetery had been re-buried in a jumble in 1956 and Gruppioni and his "Caravaggio committee" spent a year carrying out DNA and carbon-14 dating tests on the bones of some 200 people before deciding on a likely candidate. These were the remains of a man of the same age as Caravaggio who had died at the same time. Although they made headline news, some of the group's findings were somewhat staggering, such as their statement that DNA from the bones had been compared with that of at least "twenty men who could be distant descendants" of Caravaggio. There is a distinct whiff of adept marketing about this latest piece of research, not altogether surprising, perhaps, given that it concerns one of the shadiest figures in late Renaissance art history, whose death remains a mystery.

MICHELANGELO MERISI, known as CARAVAGGIO (1571–1610), *David Holding the Head of Goliath,* 1609–1610, oil on canvas, 125 × 101 cm, Galleria Borghese, Rome, Italy

One of the paintings Caravaggio sent to the pope between 1606 and 1610 to try and win his pardon was this one of David holding the head of Goliath, in which Caravaggio paints himself as Goliath. Was he showing contrition, or anticipating his own death?

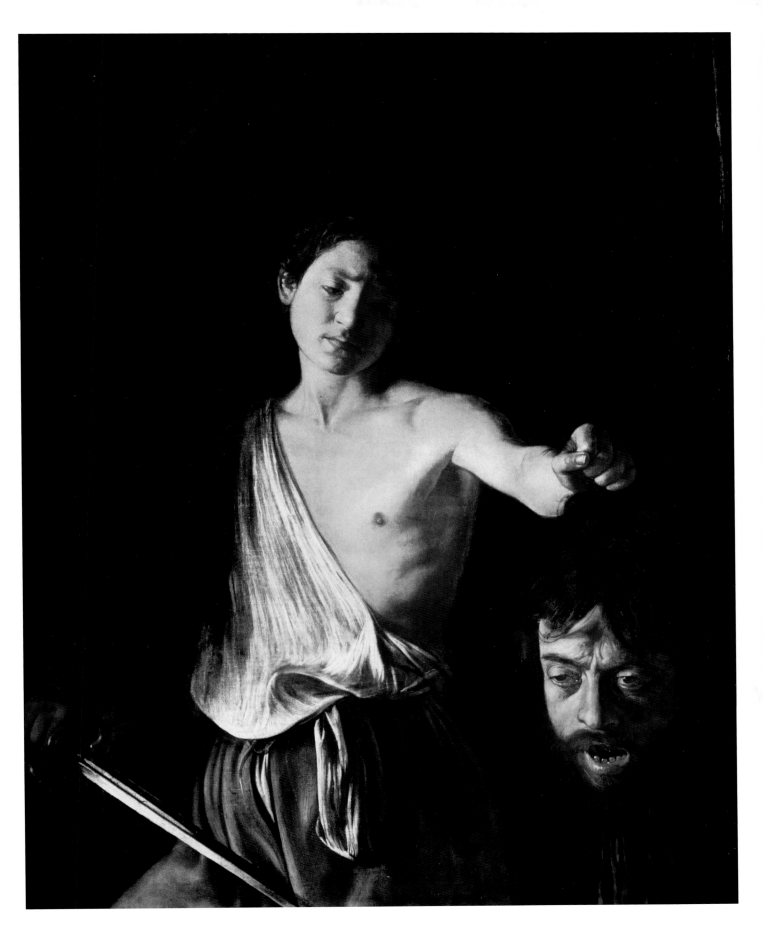

Portrait of Doctor Gachet

A
TRUE
PORTRAIT?

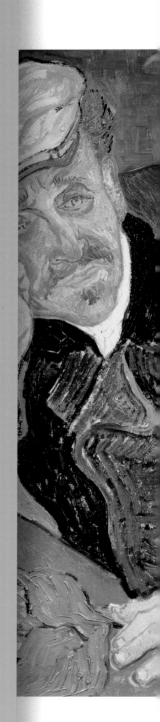

Van Gogh died on 29 July 1890 from a self-inflicted gunshot wound to the chest. Inextricably linked to Van Gogh's last days in Auvers-sur-Oise is the enigmatic figure of Paul Gachet, Van Gogh's eccentric doctor, friend and admirer. In June 1890 Van Gogh apparently painted two portraits of him. Of these, one has since disappeared while the other, in major museum, is the subject of considerable doubt.

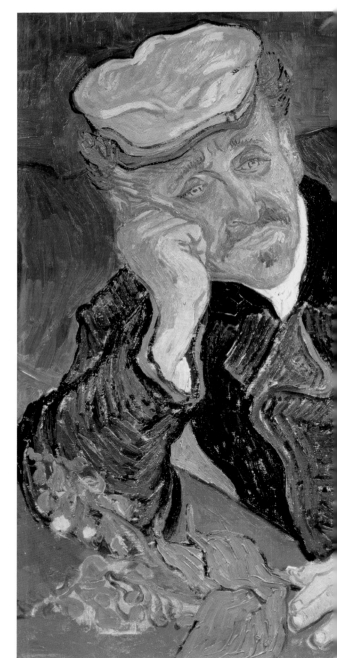

On 20 May 1890 Vincent Van Gogh left the psychiatric asylum in Saint Rémy-de-Provence for Auvers-sur-Oise. His brother Theo then recommended him to Doctor Paul Gachet, who became his friend. In a letter dated 4 June 1890, Van Gogh wrote to his brother Theo: "I am working on a portrait of him [...] leaning on a red table, with a yellow book on it and a foxglove plant with purple flowers." The painting in question has had an eventful history and no one can say where it is now. Bought initially in 1897 for 300 francs by an art dealer, it changed hands repeatedly until 1938, when it was confiscated by the Nazis, who were ruthlessly destroying any works of art they deemed "degenerate." Miraculously, the portrait escaped destruction, no one knows how; what is known is that Hermann Göring sold it on to a Dutch collector. The painting was seen for the last time at a memorable sale at Christie's New York in 1990, when the super-rich Japanese businessman Ryoei Saito bought it for a record-breaking 82.5 million dollars. It has not been seen since. It might have been expected to resurface after Saito's death in 1996 but there has been no sign of it. Some say it has found its way to Europe, others maintain that it is still in Japan, perhaps buried with its owner, who once swore he would take it with him to his grave.

There is no problem about the location of the second version of this painting—it's in the Musée d'Orsay—but there is a question mark over its authenticity. This is because this portrait of Doctor Gachet with a foxglove comes from the collection of Doctor Gachet himself, and he had something of a reputation as a faker. He was a friend of Camille Pissarro, Paul Cézanne, Pierre-Auguste Renoir, and Édouard Manet, and is known to have enjoyed copying his friends' paintings to "get his hand in." The controversy really started in 1949 when the doctor's heirs bequeathed a series of paintings to the French state that were too good to be true. No one knows how or when the portrait came into Gachet's possession, and, most importantly, Van Gogh makes no mention of it in his letters. In 1997 a leading authority on the painter declared "Gachet's collection was stuffed full of fakes." In 1999 the Musée d'Orsay put on an exhibition to prove otherwise, but failed to supply incontrovertible evidence that the portrait of the enigmatic doctor is indeed a work by Van Gogh.

Left:
VINCENT VAN GOGH (1853–1890),
Portrait of Doctor Gachet with a Foxglove Plant, 1890, oil on canvas, 68 × 57 cm,
Musée d'Orsay, Paris, France

Right:
VINCENT VAN GOGH (1853–1890),
Portrait of Doctor Paul Gachet, 1890, oil on canvas, 68 × 56 cm,
private collection (sold Christie's New York, 15 May 1990)

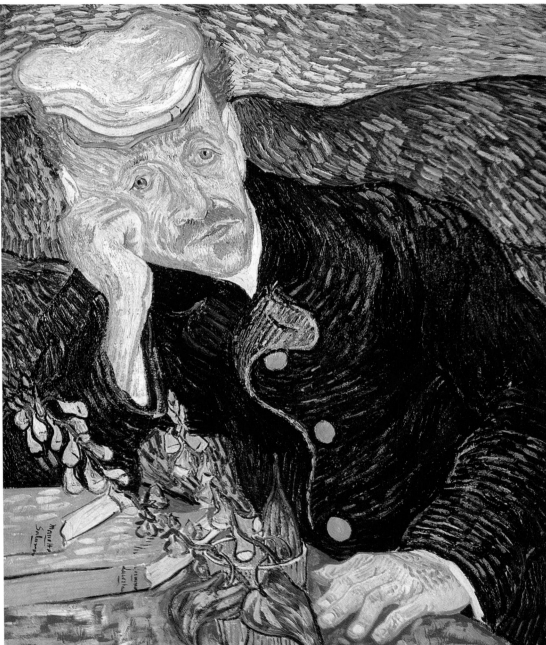

Given: 1 The Waterfall, 2 The Illuminating Gas…

DUCHAMP'S POSTHUMOUS THEATRICAL COUP

In 1968 a work by Marcel Duchamp was discovery that he'd ensured was kept hidden until after his death. This outrageous, inexplicable, absurd magic box of a work hit the art world with the force of a time bomb and remains an intriguing and controversial mystery.

In 1923 Marcel Duchamp announced that he was giving up art to devote himself entirely to his favorite pastime, chess. But at his death in 1968 there was general stupefaction when it was discovered that he had spent the last twenty years of his life creating an artwork in secret. Before he died he carefully and deliberately took steps to orchestrate its posthumous unveiling. In accordance with the last wishes of this self-proclaimed "anti-artist," the piece was presented to the Philadelphia Museum of Art, which then had the largest collection of Duchamp's work in the world. The museum thus had the onerous task of re-assembling the piece following Duchamp's minutely detailed instructions, drawn up in a large manual bearing the inscription "Approximation that can be dismantled, executed in New York between 1946 and 1966" and contained in a loose-leaf binder. The manual is densely packed with handwritten notes and over a hundred photographs, as well as plans and sketches. Duchamp left nothing to chance, detailing the smallest operation, down to exactly how the light should fall, "very vertically down onto the cunt." Technicians at the Philadelphia Museum worked flat out for three months following these instructions step by step to put the piece together.

In June 1969 the public was finally able to see what amounted to the first ever installation in the history of art. One by one, visitors could look through a pair of peepholes in a wooden door and spy a woman's body made of plaster covered in pigskin lying in the grass in front of a waterfall. With her legs wide apart, her genitals on display, she was more than a little reminiscent of Gustave Courbet's *Origin of the World* (1866, Musée d'Orsay, Paris), from which Duchamp must surely have drawn inspiration. In another curious clause, Duchamp stipulated in his will that no photographs should be taken of anything but the wooden door until 1984.

Whatever it was—a metaphor for voyeurism in art, a reflection on sexuality, a homage to some of the girls Duchamp loved—*Given: 1 The Waterfall, 2 The Illuminating Gas...* left admirers and experts alike utterly stunned. It was disconcerting and disturbing because it was so different from his earlier works. Only the artist Jasper Johns had anything positive to say about it, describing it as "the strangest work of art on display in any museum." The inventor of the ready-made must have been amused to know that he was going to mystify experts who would be busy trying to make sense of his last work. It was a mocking gesture designed to illustrate that only an artist can have complete mastery of his creations, even from beyond the grave.

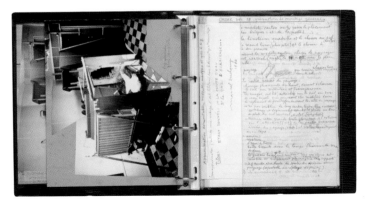

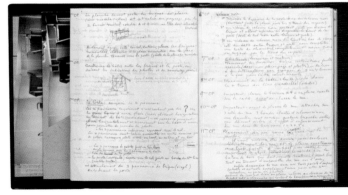

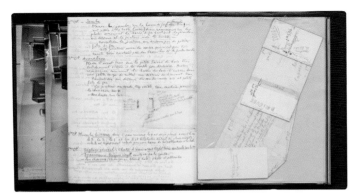

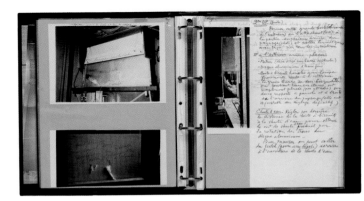

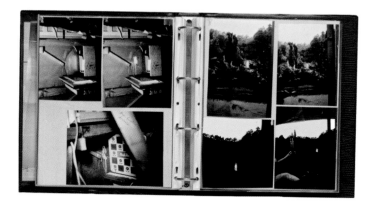

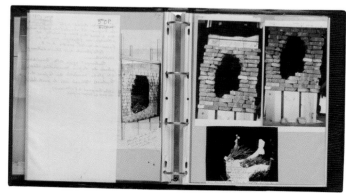

A FORBIDDEN CITY IN THE HEART OF THE NEVADA DESERT

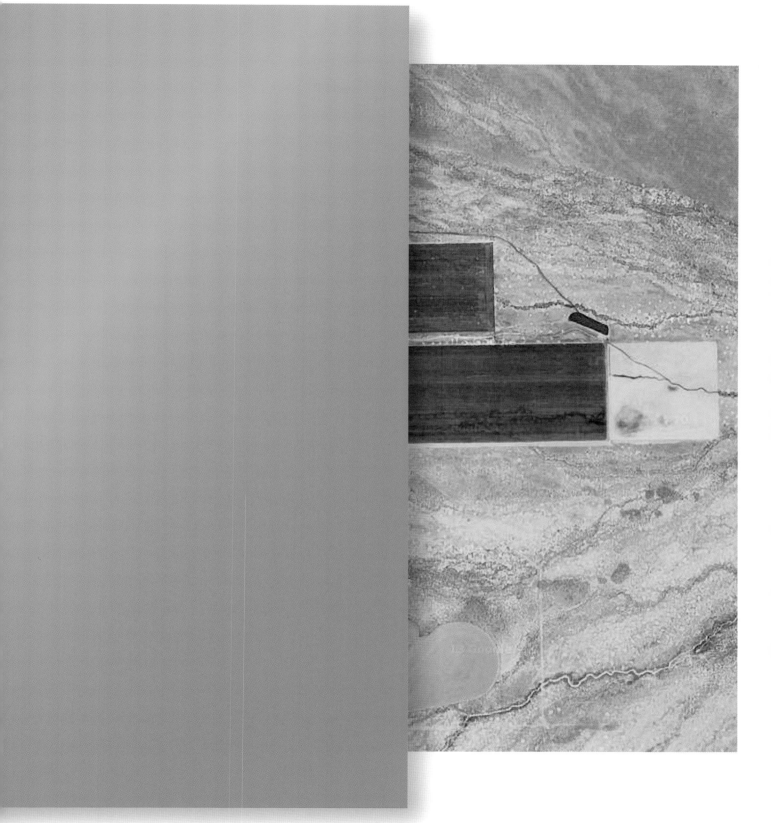

Garden Valley, a remote desert valley in Nevada, contains what is perhaps the largest art work ever devised. The only thing is, its creator wants to keep it secret and he's going to grant access to it only when the work is finished. This will not be long, say some. Others believe that will never happen.

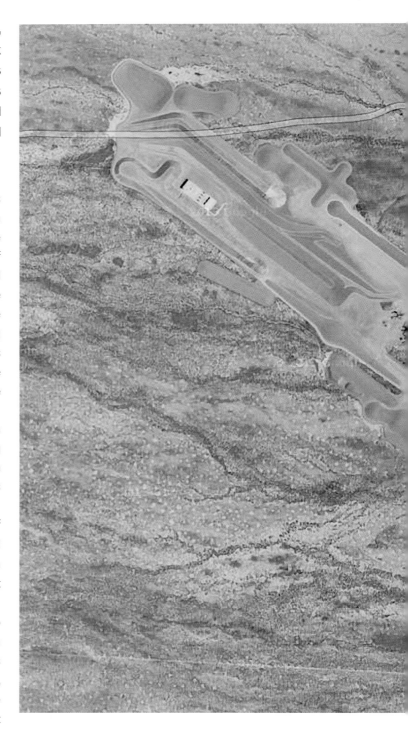

The American pioneer of Land Art Michael Heizer has always worked on a big scale. He has never gone in much for museum-sized work. In 1972 he got the idea for a monumental new project: a succession of enormous abstract sculptures in the desert to be entitled *City*. He acquired a piece of land in Nevada, two hours' drive from the nearest good road. Construction was to take place in several "Phases," each one of which would involve creating a set of different structures or "Complexes." All the parts would be linked by a network of roads and the whole piece would extend for about two kilometers, a little over the length of Brooklyn Bridge.

Influenced by his father, a specialist in pre-Columbian architecture, Heizer based his work on ancient ruins, deriving particular inspiration from the Great Ballcourt of Chichen Itza, the mysterious Mayan city in the Yucatan peninsula, as well as from the pyramid of Djoser at Saqqara in Egypt.

Work began on a vast construction site with a small army of machines: cranes, containers, cement mixers…: "We used everything, almost every tool in the whole construction catalogue on just this one structure," said the artist about Complex One.

In 1980 Heizer moved on first to Complex Two and then to Complex Three. But the project was still far from completion and the money began to run out. Heizer gave up work on his massive enterprise to concentrate instead on smaller-scale, more cost-effective ventures. At the end of the 1990s, he even contemplated destroying what had already been built of Complex Two and Complex Three and keeping just Complex One. This was not to be, however: several foundations were convinced of the value of the ultimate artwork and came forward with funding for the "works" to continue.

The artist still remains vague as to when the extraordinarily ambitious project will be completed. In theory it was to have consisted of five "Phases" and should have been completed in 2010. It was then announced that it would be ready in 2013—but there is still no sign of completion. Meanwhile

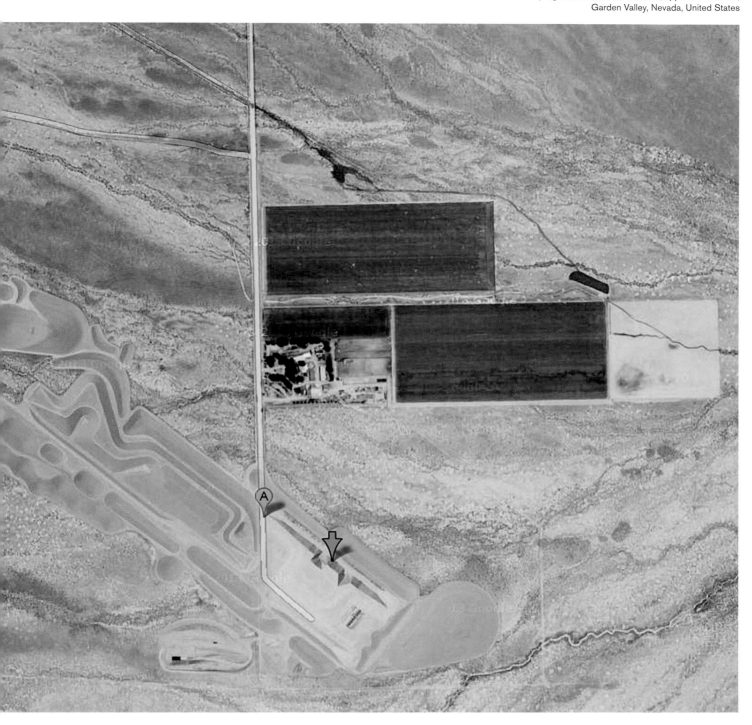

the site remains private property and access is restricted. In over forty years since the work began, Michael Heizer has given very few interviews and allowed only a handful of journalists to set foot in the place, doubtless weary of seeing planeloads of curious sightseers flying over his life's work. In all probability only about a fifth of *City* has been finished and the artist has no intention of opening the doors to the public until the four following "Phases" are complete. Until then, no one can say for sure what this modern-day temple complex will contain.

IDENTITY

Anyone who's interested in art naturally wants to know an artist's name, find out something about his or her life, discover who the model was for a particular figure. Ours is very much a culture of the individual and this affects how art is produced and how it's studied. Artists these days are celebrities who generally know how to make the most of their public image. Even Banksy (page 80), who goes to great lengths to conceal his identity, contrives to conjure up an intriguing image in the process. There was a time, however, when none of this mattered very much.

In the Middle Ages, painters and sculptors were thought of as artisans who produced precisely what clients asked them to. With very few exceptions, it didn't really matter who produced an art work; what mattered was that an artist should be able to turn out a work in line with established canons, contemporary conventions, and the commissioner's specific requirements. From the Renaissance onwards, however, artists became increasingly aware of their individual status and sought recognition—and reward—for their talents. The sixteenth century saw the publication in Italy of Vasari's *The Lives of the Most Excellent Painters, Sculptors and Architects*. It was the first book in art history to give any importance to the lives, character, and unique talents of individual artists.

Establishing the identity of a particular model can be even more difficult. Who cares about some poor woman who is paid next to nothing to serve

as a model for a figure in some allegory or biblical or mythological scene? We certainly do today: the people artists chose as models seem to link directly to what the artists themselves were like and how they went about their work. Caravaggio, for instance, is said to have got beggars and prostitutes to pose as biblical characters. Some artists, including Hans Holbein the Younger in the sixteenth century and Théodore Géricault in the nineteenth, worked from cadavers, even though the practice was strictly forbidden. Many borrowed the features of a loved one, such as a spouse or lover; others chose to incorporate themselves into their works, as Bosch may have done in the panel devoted to Hell in *The Garden of Earthly Delights* (page 140). More is generally known about people who sat for portraits. The great and the good who had their pictures painted tended to be rich and influential enough for us to know something of their lives.

There is one final category of people who can be difficult to identify: the figures depicted in works of art. While the Bible and the lives of the saints may have been common knowledge to the people who commissioned early works of art, art lovers nowadays do not have the benefit of such knowledge at their fingertips. It can be hard for them to decipher the symbols and attributes that confront them, but these mysteries can generally be solved with a little research. The same is sadly not true of the many artists and models whose mysterious identity not even the most assiduous researchers can penetrate.

IS THIS TRULY THE FACE OF THE LEGEN- DARY KING OF MYCENAE?

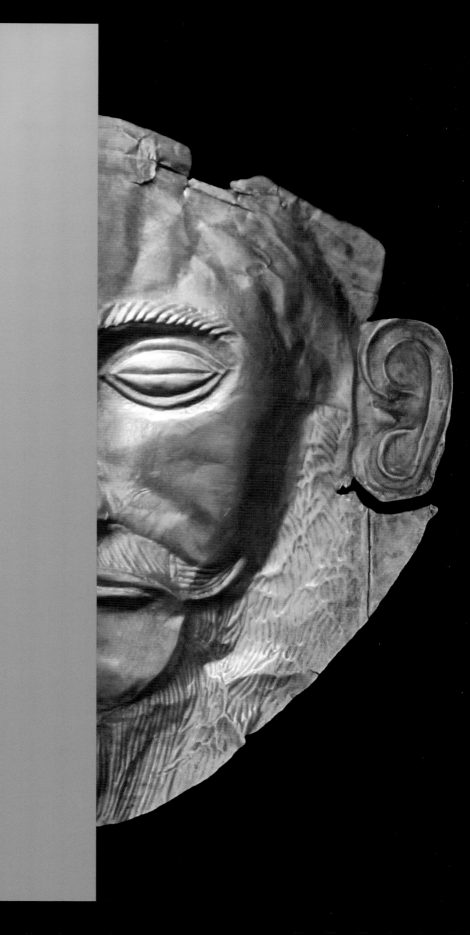

In the *Iliad* Homer tells how the Greeks laid siege to Ilium (Troy) after the Trojan prince Paris made off with the wife of one of their kings, the incomparably beautiful Helen. Ancient though it is, Homer's epic tale of war, love and death is woven into the very fabric of European culture and continues to fascinate us to this day. It's little wonder, therefore, that in the nineteenth century someone like Heinrich Schliemann, dreamer and keen amateur archeologist, should have tried to uncover historic evidence for a myth that might prove not to be one at all.

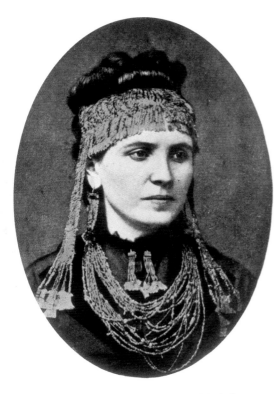

Schliemann's wife, Sophia, adorned with jewels from "Priam's Treasure," photographed in 1874

Born into a poor family, German businessman Heinrich Schliemann developed a zeal for both travel and for ancient languages, which he taught himself. Convinced that the tales of Homer referred to real events, he set about finding the places mentioned in the *Iliad* and the *Odyssey*.

In 1871 he uncovered the ruins of the city of Troy in Hissarlik, in what is now Turkey. Only two years later he made the most extraordinary discovery of his life: he unearthed a collection of exquisitely crafted gold and silver weapons, utensils and jewelry that he declared was the "treasure of Priam," the mythical king of Troy. With his wife's help, he whisked his discovery away from under the eyes of the Ottoman authorities and as a result found himself barred from staying in the Ottoman Empire.

While Schliemann was generally recognized as having some first-class excavating skills, the authenticity of the treasure was challenged. Schliemann was accused of artificially assembling a collection of disparate objects in order to support his theories. He was vilified in academic circles and roundly condemned for his lack of conventional training, his extravagant ways, and his doubtful links with the press. The imputation was that Schliemann was no simple overzealous traveller, but an impostor.

Far from allowing this to put him off, the German archeologist carried on pursuing his dream. In 1874 he went to Greece and began digging at Mycenae. Two years later he discovered there a funerary mask in pure gold which he tried to persuade experts was that of Agamemnon, the king of the Achaeans who appears in the *Iliad* and the *Odyssey*. Because Schliemann had a reputation for obsessively secreting artifacts in sites where he was digging to support his theories, some people believed that he had had the mask made in advance and then simply deposited it when an opportune place presented itself. It was inconsistent with other finds from the site, and there were errors in dating … everything pointed, it was argued, to this not being the tomb of Agamemnon. But who knows? Opinion remains divided.

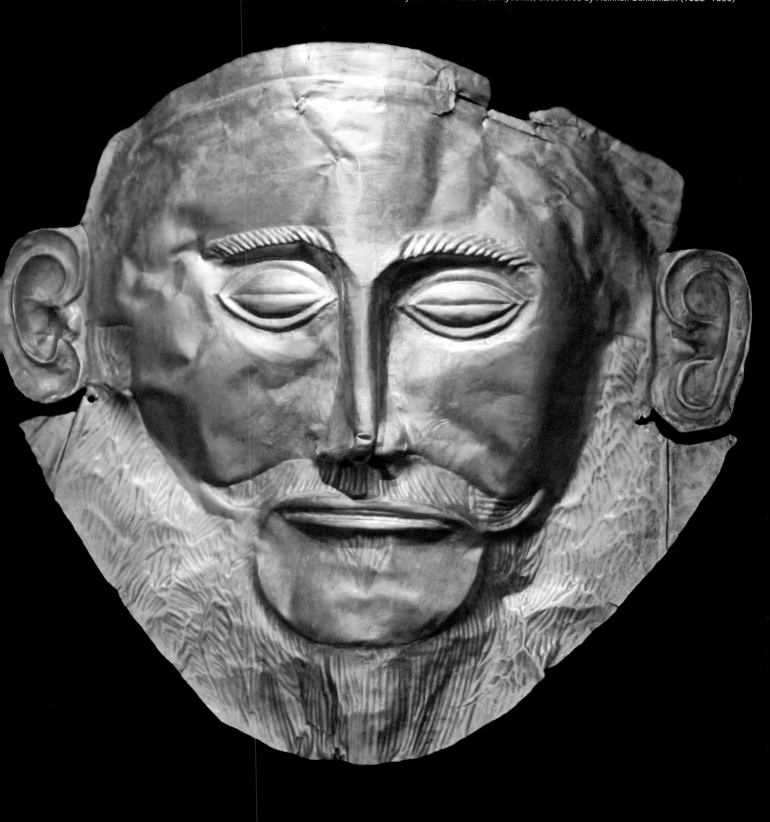

FORGOTTEN ARTISTS AND BYGONE SAINTS

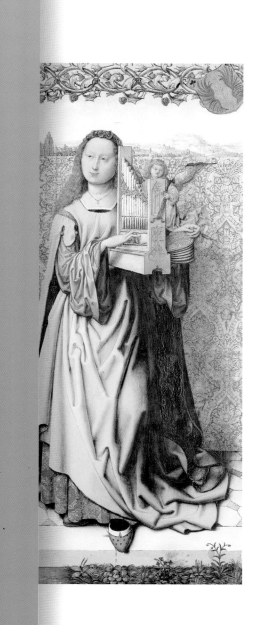

The Master of the Saint Bartholomew Altarpiece was a major artist in late fifteenth-century Europe, yet we know very little about him. Not even his name has come down to us. The *Saint Bartholomew Altarpiece* is emblematic of a period when artists were eclipsed by their works. Anyone trying to get to grips with it today is likely to find it perplexing: not only is there an absence of information about it, but the figures it contains are obscure and not easy to identity.

The artist we call the Master of the Saint Bartholomew Altarpiece, for want of further information, probably worked in Cologne. His style was Late Gothic and clearly little affected by the stirrings of the Renaissance. Artists in the Middle Ages did not have the status they are given today. They were classed as artisans on a par with all other manual workers in a way that to us might seem to devalue them. Even as late as 1613, Charles Loyseau placed them at the bottom of the social scale in his *Treatise on Orders and Simple Dignities*, just above laborers. That is why we generally know so little about artists before the Renaissance. Like the unknown master of the present painting, for the most part they did not sign their works. They were not expected to come up with innovations of any kind and even less to display any originality: their brief was to depict precisely what they had been commissioned to, and according to well established rules.

The altarpiece follows the aesthetic canons of the Middle Ages. The saints it depicts would have been easily identifiable at the time from *The Golden Legend* written by Jacobus de Voragine in the thirteenth century. Widely known, this book describes the exemplary lives and martyrdoms of the saints, giving chapter and verse of their persecution, and identifies their defining characteristics or attributes. Bartholomew, for example, was one of the twelve Apostles who set off to preach the Gospel in Armenia and India. When the locals failed to make him abjure his faith, they flayed him alive (or cut off his head, as another tradition would have it). He is represented in painting with a knife and sometimes his own skin over his arm. As a result he became the patron of flesh and leather workers (butchers, tanners…). There is no narrative significance to the knife he holds in the altarpiece: it's an emblem that allows any viewer who knows his story to identify him easily. In the same way, the figure at his side can be identified as Saint Agnes by the lamb which accompanies her (*agnus* in Latin, which reminds us of Agnes, and a symbol of purity in its own right), and Saint Cecilia by the organ that is her defining attribute (the story has it that she did not listen to the organ playing at her enforced wedding to a non-Christian, her mind being focused solely on God). In the Middle Ages, the stories of these saints may have been more important than the life or originality of the artist, but the individual talent of the Master of the *Saint Bartholomew Altarpiece* comes through his work nevertheless, making him famous in his day and still admired today. It's so distinctive, in fact, that we have been able to attribute other works to him without knowing for sure who he was.

MASTER OF THE SAINT BARTHOLOMEW ALTARPIECE (FLOURISHED C. 1475–1510),
Saint Bartholomew Altarpiece, central section showing Saint Bartholomew, Saint Agnes, Saint Cecilia with a donor, c. 1500–1505,
oil on wood, 128.6 x 161.3 cm high, Alte Pinakothek, Munich, Germany

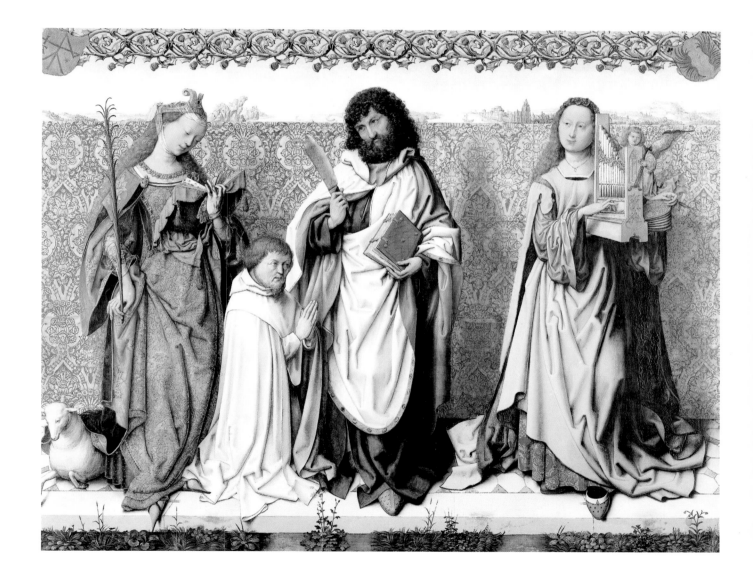

WIFE AND MOTHER, OR PROSTITUTE?

We all think we know *The Mona Lisa*: it's incredibly famous, attracting not only millions of visitors eager to see the sitter's mysterious smile for themselves, but also an endless succession of experts and enthusiasts bent on deciphering its meaning. Yet this strange painting continues to raise too many questions for comfort: Who is this young woman painted like a contemporary prostitute? What is the artist doing with that revolutionary smile and distinctly chaotic and hardly decorative setting? And why did he hold on to the painting all his life?

To try to get to the bottom of the mysteries surrounding *The Mona Lisa*, we need to go back several centuries, to Renaissance Florence. Francesco del Giocondo was a successful merchant in the city who had everything he could desire: he was rich, he had just bought a house, and his twenty-three-year-old wife had given him the sons he had hoped for. Wanting to honor her, he called on the greatest painter in the city, Leonardo da Vinci, to paint her portrait. But in place of the image he might have expected of a virtuous and fecund wife and mother, Leonardo produced a picture of an apparently immodest woman. The husband was reputedly furious at such perceived impropriety and refused to accept the portrait. It is true that in some ways the young wife is depicted as a woman of easy virtue: her eyebrows are plucked, her wide forehead is immodestly exposed, and she looks out unashamedly at the viewer, a smile on her lips. This is why some people have questioned if this really can be a portrait of the respectable wife of the Florentine merchant. The fact that there is no surviving documentary evidence of the commission has only added fuel to the fire: indeed, the first mention there is of the commission is in a biography that was not written until several years after the artist's death.

The smile was Leonardo da Vinci's invention. The only artist to attempt anything remotely similar before him was Antonello da Messina (*Portrait of an Unknown Man*, Museo della Fondazione Culturale Mandralisca, Cefalù), though his laughing man's strange half-grin has nothing in common with the gentle, subtle smile of *The Mona Lisa*. Was it just a piece of whimsy on da Vinci's part, an excuse to show off his technical skill? Or was it designed to evoke, as the art historian Daniel Arasse suggests, a happy, fulfilled woman whose husband gives her everything she could wish for? Leonardo painted only two portraits in Florence. The other, *Portrait of Ginevra de'Benci* (National Gallery, Washington, DC) is also of a woman, but unlike the sitter in *The Mona Lisa* she looks gloomily out at the viewer, her lips pursed together sadly. Like the Mona Lisa's, her expression reflects her situation: her lover is far away. The picture captures more than the woman's face, it attempts to convey the emotion she is feeling.

As well as reflecting a deeply felt emotion, the smile can also be seen as symbolizing the fleeting nature of existence. This is supported by the presence of the water in the background below the bridge, traditionally used to represent time passing, and by the apocalyptic-seeming landscape that looks devoid of all human life.

Leonardo da Vinci was to keep this painting with him for the rest of his life. It was more, perhaps, than just another picture: it was his summation of personal reflections on painting, portraiture, and the transience of life.

LEONARDO DA VINCI (1452–1519),
Portrait of Lisa Gherardini, also known as ***The Mona Lisa*** and ***La Gioconda,*** c. 1503–1506, oil on wood (poplar), 77 × 53 cm, Musée du Louvre, Paris, France

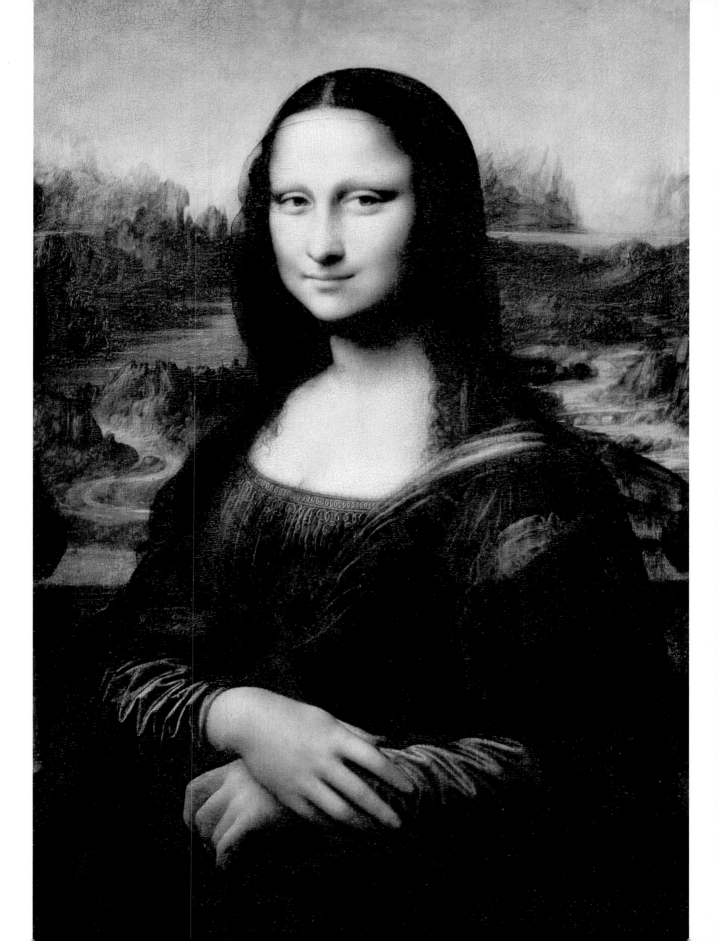

TOO UGLY
TO BE TRUE

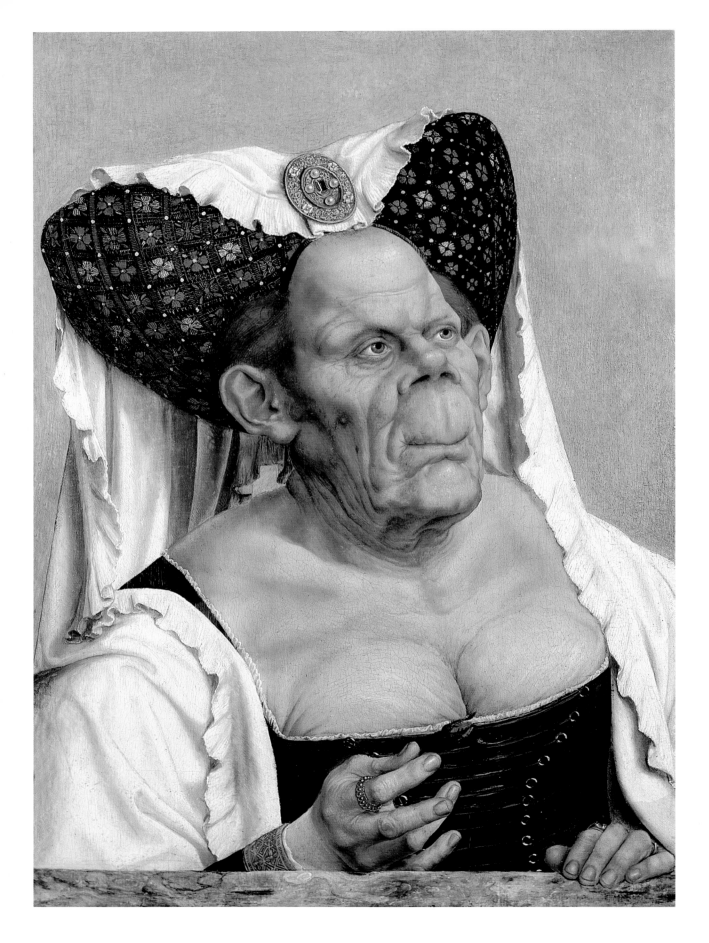

Renaissance humanism set man and his individuality at the heart of everything, and portraiture as an art form was at its peak in the fifteen and sixteenth centuries. It was a period that produced the most famous portrait in the world, *The Mona Lisa*, admired for its subtlety and elusive meaning. Ten years later, the Flemish artist Quinten Massys painted what appears to be an allegory of ugliness: an old woman so deformed that it's almost impossible to believe that she could be anything but a product of the artist's strange imagination, let alone a real person. Recent discoveries, however, perhaps indicate otherwise.

Ugliness is at least as compelling as beauty, if not more so, as is shown by the impact of *The Ugly Duchess*, also know as *An Old Woman*, on art historians keen to solve the mystery of her identity. Massys was long thought to have modeled his work on two grotesque drawings of busts of old women attributed to Leonardo da Vinci. According to this view, the Flemish artist's work is also a caricature: an illustration of the consequences of not coming to terms with old age, rather than a portrait of a real person. The poor dowager in the picture is trying to recover her lost youth: she is elaborately dressed, but in clothes that are sadly out of fashion. The rosebud completes the impression of a touching but ridiculous figure: a symbol of passion, it clearly indicates that she is trying to be seductive.

In the nineteenth century, the illustrator Sir John Tenniel based his drawing of the Duchess in Alice's Adventures in Wonderland *on this picture.*

This theory was then turned on its head. It was Leonardo who was thought to have modeled his drawings on the portrait by Massys. Attention then turned to who this hideous woman could possibly be. Various names were proposed, including that of Margarete Maultasch (1318–1369), wife of John Henry of Luxembourg, who left him to marry Louis I of Brandenburg and as a result was excommunicated, along with her new husband, by Pope Clement VI in 1342. The story famously earned the duchess the nickname "Maultasch" ("bag mouth"), the equivalent of "prostitute" in Bavarian dialect, and provided Massys with the perfect vehicle for a satire on seductresses … or so the theory goes. Although this theory still has supporters, it's questionable: there is no evidence that Margarete's appearance was anything but pleasant, as shown by other images of her.

Until recently, critics have neglected one crucial aspect of the picture that sheds considerable light on its history. *An Old Woman* is only one half of a diptych. The other half is in a private collection and therefore little known. It features a male counterpart, who is not hideous in any way, which suggests that this might in fact be a double portrait of a real couple. What then can have happened to the wife? In 2008 a doctor, Michael Blum, declared that the female sitter obviously suffered from Paget's disease, an affliction of the bones that can cause the skull to become deformed. If this is true, why did Massys not do his best to tone down her features to please the man who had commissioned the picture, as he would have been wise to do in that day and age? History does not relate…

QUINTEN MASSYS (1465–1530),
The Ugly Duchess, also known as **An Old Woman,** c. 1513,
oil on wood (oak), 62.4 × 45.5 cm, National Gallery, London, United Kingdom

"NO OTHER PAINTING BY RAPHAEL HAS PROVOKED SUCH CONFLICTING REACTIONS."

Daniel Arasse

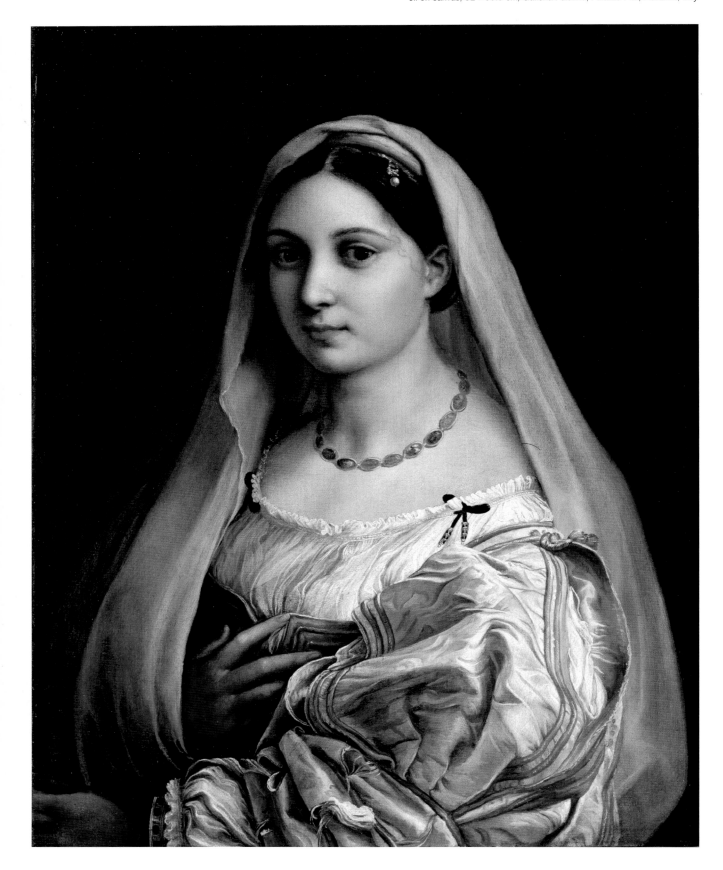

RAFFAELLO SANTI OR SANZIO, **known as** RAPHAEL (1483–1520),
La Fornarina, c. 1520,
oil on wood, 87 × 63 cm, Galleria Nazionale d'Arte Antica di Palazzo Barberini, Rome, Italy
This portrait is commonly attributed to Raphael but sometimes also to Giulio Romano, one of his pupils

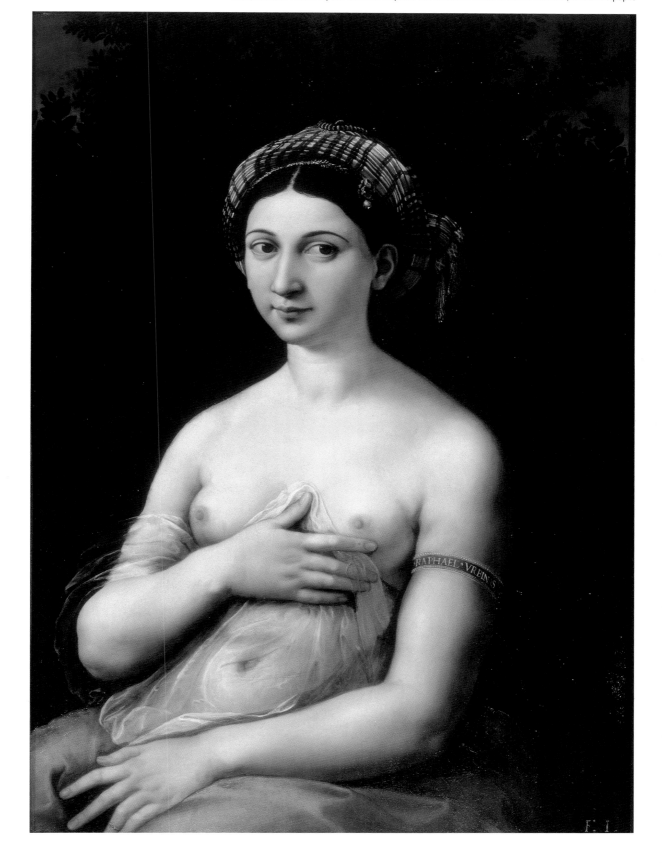

When Raphael died in 1520, a painting was discovered in his studio that he wanted, it seems, to keep well out of sight. Undated and untitled, this mysterious work is nothing like Raphael's other portraits of women and raises a number of insistent questions. Who is this woman? Was she Raphael's mistress, perhaps even his secret wife? Is she the woman we see in other paintings by him? Is it a genuine Raphael?

In the last few years of his life, by then based in Rome, Raphael was held in exceptionally high regard. He received many public commissions and was universally acclaimed for the harmony of his compositions and the accuracy and sensitivity of his treatment of faces. A reasonable amount was known about both his life and his work, but all this was to be thrown into question by a single painting, *La Fornarina*, probably painted around 1520. The identity of the woman, who is shown wearing a narrow band around her arm with Raphael's name on it, continues to intrigue both art historians and the general public.

In the early seventeenth century she was identified as one of Raphael's mistresses, the woman he set up in lodgings on the site of the Villa Farnesina in Rome so that he could have her permanently with him. Later that century, people maintained that she was a young woman with whom Raphael was deeply in love until his death. In the eighteenth century the painting was finally dubbed *La Fornarina*, "the baker's daughter." The portrait was held to be of Marguerita Luti, daughter of a baker from Siena who was probably Raphael's last mistress, the one he loved most. According to the writer Giorgio Vasari, Raphael died while making love and Marguerita was so overcome with grief that she shut herself up in the convent of Santa Appolonia to die. This romantic tale caught the imagination of the critics and the public and the painting became very well known. As its fame spread, all sorts of theories sprang up as everyone sought to unlock *La Fornarina's* secrets. Some, for instance, seized on what looks like a wedding ring on her left hand and maintained that this betokened that she and Raphael were secretly married.

There has been a similar amount of debate about the authorship of the painting, with some experts maintaining that the draftsmanship was far too crude to be by the hand of the master. In the context of the countless delicate, diaphanous women painted by Raphael, be they Madonnas, saints, classical graces, or simple mortal women, *La Fornarina* stands out jarringly. Everything about her, from her transparent veil, which reveals more than it hides, to her sideways look and teasing smile, breathes sexuality and conveys a frank eroticism that we are not used to seeing in Raphael's work. Nevertheless, some wondered if there is not a link, and a delightful one at that, between *La Fornarina* and *La Donna Velata*, an earlier painting that displays some notable similarities.

In the nineteenth century the mystery took another twist when the French artist Ingres produced a series of paintings depicting the Italian painter with *La Fornarina*, in both painted and human form, subtly giving us his own distinctive take on their relationship.

JEAN-AUGUSTE-DOMINIQUE INGRES (1780–1867),
Raphael and La Fornarina, 1814,
oil on canvas, 64.8 × 53.3 cm, Harvard Art Museums, Cambridge (Massachusetts), United States

The Le Nain Brothers

THREE ARTISTS, ONE SIGNATURE

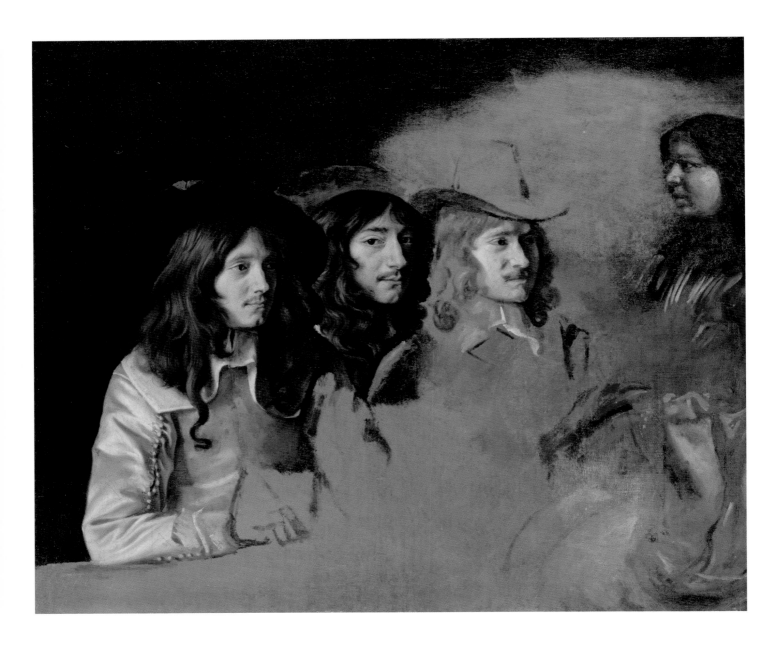

The artist Le Nain is notable in one respect: he never existed. The Le Nain brothers, on the other hand, did: Antoine, Louis, and Mathieu worked in the same studio. Their output was prodigious and their works were in demand, but strangely almost nothing is known about them, not even when they were born.

Between the three of them, the Le Nain brothers are thought to have produced some 2,000 paintings, though only seventy-five identified works have come down to us. How is it that we know almost nothing about them?

It's difficult to tell the work of the brothers apart for two main reasons. The first is that the three were so close to one another that none of them had any desire to be set apart from the other two, and so they habitually signed themselves simply "Le Nain." The second is that, although they were famous in their lifetime, it was a time when the prime focus was very much on the work rather than the creator and as a result no one was particularly bothered to establish which Le Nain was which. The Le Nain brothers subsequently disappeared from view: in an age dominated by academic art, people were not very interested in their realist depictions of peasant life. It was not until the mid-nineteenth century, thanks notably to the French writer Champfleury, who was a great admirer of the three brothers, that their collective genius was rediscovered. Their pictures resurfaced and dealers and critics began to try to distinguish between them. Time had passed, of course, and it became more and more difficult to discover anything remotely reliable about their lives.

No picture can be attributed with any certainty to one brother or another. It is even possible that some paintings are the work of several hands.

It's really only in the last few years that there has been any sustained attempt to distinguish between their different hands and to set them apart as individuals. There have been many theories, all of them different, attributing paintings to specific brothers. The most widely accepted view is that of Paul Jamot (*Le Nain*, 1929), that the youngest of the three, Mathieu, painted the group scenes, Louis, the peasant scenes, and Antoine, the miniatures. But we need to be careful here; we are on shifting sands with the Le Nain brothers. So far no theory, however attractive, has held up when applied to their work as a whole. Experts are left baffled, as they are by the picture shown here, which is a perfect illustration of the kind of difficulty the Le Nain pose. The three figures in the foreground are widely thought to be the three brothers, though the picture was once known as *A Trio of Geometers* because of the presence of a globe and geometer's instruments (now lost after cleaning). When it was restored in 1968, however, a fourth figure—a young man seen in profile—appeared at the end of the table. Who is he and what is he doing in this family group? Is it possible that this group portrait is only part of a larger whole and that it may just hold one of the keys to the mystery of the Le Nain?

ANTOINE (BETWEEN 1597 AND 1607–1648) AND/OR LOUIS (BETWEEN 1597 AND 1607–1648) AND/OR MATHIEU (C.1607–1677) LE NAIN, **Three Men and a Boy** (formerly known as **A Trio of Geometers**), c. 1647–1648, oil on canvas, 54.1 × 64.5 cm, National Gallery, London

The Self-Portraits of Rembrandt Harmenszoon van Rijn

THE HIDDEN FACE OF REMBRANDT

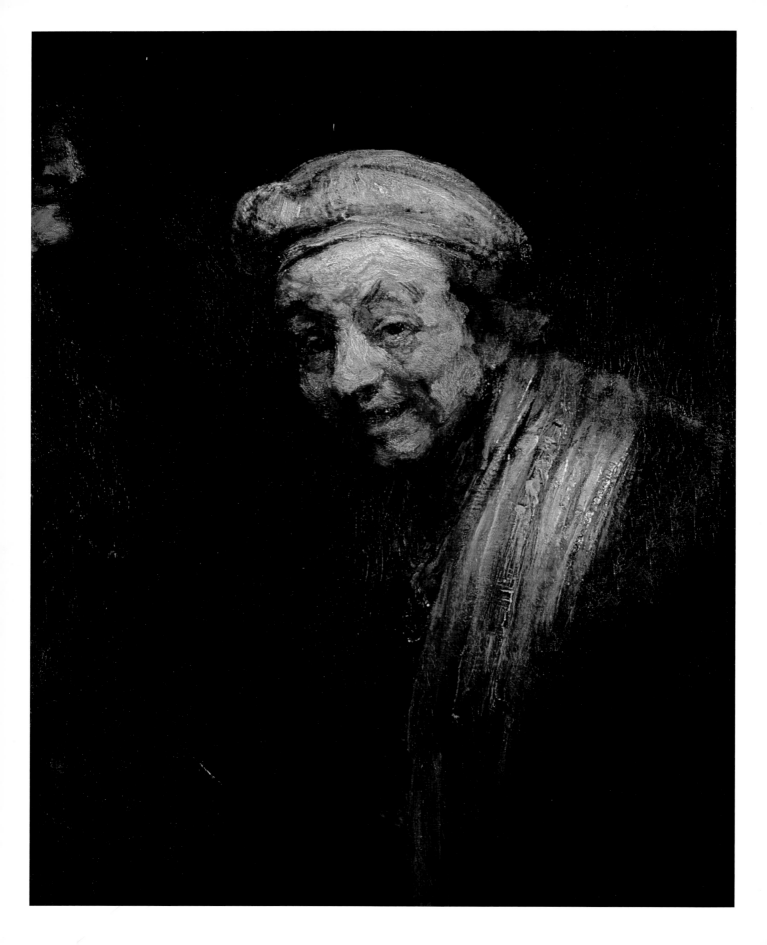

Rembrandt painted, drew or engraved a hundred portraits of himself in the course of his life. Such devotion to self-portraiture is unusual in artists at any period in art history; in Rembrandt's day it was unique—he was truly alone in his commitment to the practice. What was behind such an obsessive pursuit?

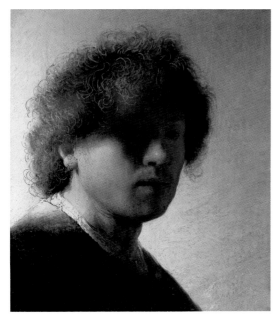

Above:
REMBRANDT HARMENSZOON VAN RIJN, known as REMBRANDT (1606–1669), *Self-Portrait,* c. 1628, oil on panel, 22.6 × 18.7 cm, Rijksmuseum, Amsterdam, The Netherlands

Rembrandt was the undisputed master of the Dutch Golden Age of painting, known not only for his virtuoso use of chiaroscuro, and for his biblical and mythological scenes, but also for his remarkable series of self-portraits. Surprisingly, however, to date there is no catalogue raisonné of these heads or *tronies* (a Dutch term used to describe studies of "expressions" or "faces") now scattered in some thirty collections across the world. Let's try and imagine what it would look like if we could assemble all the "portraits of Rembrandt by himself" in sequence, from the very first, a nervous-looking figure in the middle of the crowd in *The Stoning of Saint Stephen* (Musée des Beaux-Arts, Lyon) painted in 1625, right through to the very last, produced in the year of his death, where he depicts himself as an old man. What would we learn from this? The answer, paradoxically, is not much, and it is precisely this that makes these self-portraits so compelling. We still do not know what he really looked like in daily life. He doesn't show us who he was or where he lived: he always paints himself either in costume or in his artist's tunic, and never betrays anything truly personal.

Rather than showing us anything about his personal world, which the Dutch master clearly did not want to do, it could be argued that Rembrandt used self-portraiture largely to demonstrate his style and technical skill, and that the accessories he depicts himself wearing—pieces of armor, gold chains, rich Oriental fabrics—are chosen primarily to show off his talent and his meticulous attention to detail.

But this unique set of self-portraits amounts to more than a technical exercise. Rembrandt shows himself in every conceivable mood—serious, melancholy, jolly, self-satisfied—and the power of these portraits is enhanced by his use of Caravaggesque contrasts of light and dark. There is very definitely an introspective and melancholic aspect to this work. In his last years he charts his own advancing old age unflinchingly: his furrows get deeper, his features blurred, his hair whiter, and his expression increasingly weary. One portrait among these late works is particularly intriguing. This is the *Self-Portrait as Zeuxis*, in which Rembrandt portrays himself as old and laughing in the guise of the Ancient Greek artist who is said to have died laughing at a picture he had painted of a funny-looking woman—just one of the many intriguing and enigmatic faces of Rembrandt.

Opposite:
REMBRANDT HARMENSZOON VAN RIJN, known as REMBRANDT (1606–1669), *Self-Portrait as Zeuxis,* c. 1668, oil on canvas, 82.5 × 65 cm, Wallraf-Richartz Museum & Collection Corboud, Cologne, Germany

Girl with a Pearl Earring

THE MONA LISA OF THE NORTH

Jan Vermeer's life and work are both steeped in mystery. *Girl with a Pearl Earring* is no exception and so intrigues critics that it has become known as the "Mona Lisa of the North." It prompts question after question. Who is the model? What are we supposed to make of her expression, or of the glowing pearl at the center of the picture?

Out of thirty-seven pictures known to be by Vermeer, thirty-two feature women or girls. Vermeer was nicknamed the "Sphinx of Delft" in the nineteenth century because of the mystery surrounding him, and this extends to his models. We know very little about them in general. If the identity of the *Girl with a Pearl Earring* has provoked particular debate, it's because of the perplexing way in which she is dressed. The different parts of her dress are incongruous and give viewers contradictory clues to her identity.

Taken on its own, the pearl might lead us to think that this is a young middle-class woman sitting for a commissioned portrait. But this supposition is immediately undermined both by the blue and yellow headdress—of a type rarely seen in Holland in the seventeenth century—and by the coarse and not very becoming brown smock that looks more like something a servant would wear. It's virtually unthinkable that anyone should have commissioned a portrait of a servant disguised as a well-to-do woman. People have therefore speculated that this is a *tronie* (Dutch for a "face"), one of those studies of heads very much in vogue at the time, in which the focus is on illustrating a particular attitude or expression rather than on the identity of the sitter. The suggestion is that Vermeer is trying his hand here at an exotic type, a Turkish-style *tronie*, hence the surprising headdress. Since we know that the painter almost certainly did not have the means to pay a model, he probably had to ask someone in his immediate circle to pose for him: a member of his family, perhaps, or a neighbor, a friend or a servant.

The American writer Tracy Chevalier was inspired by the mystery surrounding this picture to write a novel in which she imagined that the model was a servant in the Vermeer family.

The identity of the young woman is not the only thing that is puzzling about the picture—and in fact if we accept the theory that this is a *tronie*, it ceases to be of any importance. What we really wonder about is the meaning of the picture. We are left asking ourselves why Vermeer chose to make the model strike the particular pose she does, standing in profile, her head turned to the side, looking at the viewer, her lips slightly apart. Her mouth seems about to open—has she got something to tell us? This unknown girl is both simple and sensual, and slightly unnerving. She has the candid expression of a child and the look of a woman casting a last gaze at a lover. There is a tension and an ambivalence about her which culminate in the glowing pearl in her ear. Our eye travels naturally from one area of light in the picture to another—the corners of her lips, the folds in her headdress—until it reaches this single drop of light. The pearl is a window in an otherwise closed scene and we find ourselves drawn into the painting as if the girl herself were silently inviting us to share her secret.

JAN VERMEER (1632–1675),
Girl with a Pearl Earring, c. 1665,
oil on canvas, 44.5 × 39 cm, Koninklijk Kabinet van Schilderijen Mauritshuis, The Hague, The Netherlands

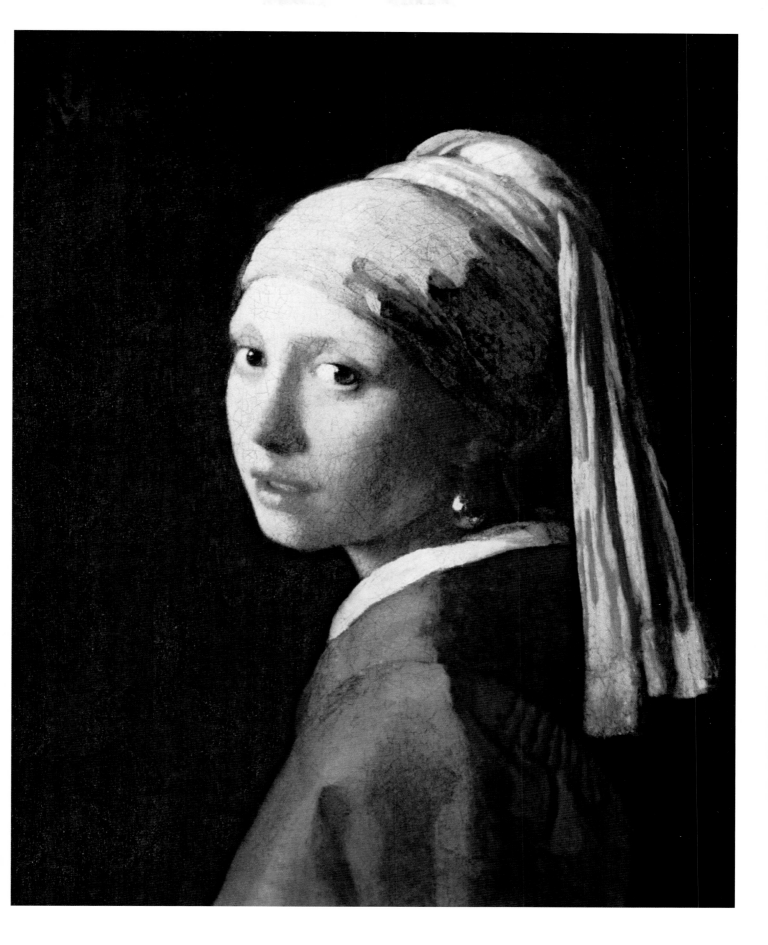

ON THE HEELS OF THE MOST SECRETIVE STREET ARTIST IN THE WORLD

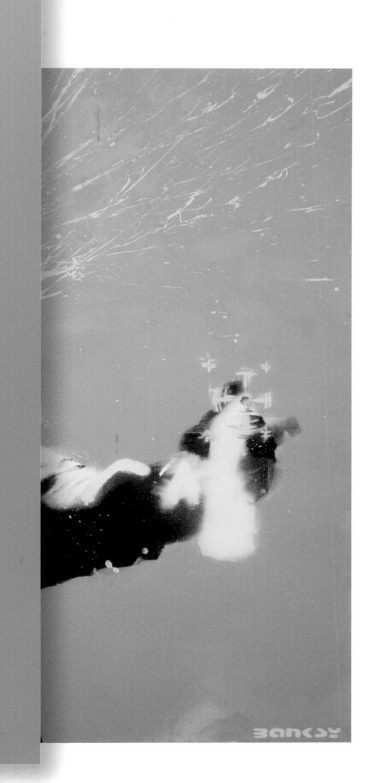

In the space of just a few years, Banksy has become an international phenomenon, with people falling over each other to buy his works on the rare occasions they come up for sale. Yet we know virtually nothing about him. He might not even be a single individual but a group of artists. Whoever he is, he likes to keep his true identity hidden and to make the most of the mystery he so adroitly creates.

Rarely has an artist been the subject of so many rumors and myths in his own lifetime. Like most street artists, Banksy uses a pseudonym. This is because for the most part he works illegally, street art historically being deemed an act of vandalism. But since 2000 there has been something of a sea change. The art market realized that there is money to be made from street art and now gives extraordinary exposure to an art form that it once dismissed as peripheral, possibly even dangerous. Anyone coming across Banksy's graffiti, collages, installations and stencils where he mainly works, in the streets of Bristol and London, is likely to be won over immediately: there is a humor and subversive element to his works that gives them an instant and almost universal appeal. He pushes political engagement to the limits with an irreverence it's difficult not to admire; in Gaza, for instance, he created an image of children playing on an idyllic beach—depicted on the wall dividing Israel and Palestine.

Banksy set up a 'Pest Control' site on the Internet as the only means for authenticating or selling any of his works.

Unlike some of his peers, however, Banksy has not been seduced by the lures of celebrity: he refuses to reveal his identity, does not give interviews, and carries on quietly working by night in public places, leaving unsated the dealers' thirst for profit. When he organizes a sale, he always carefully contrives to preserve his anonymity.

It seems almost inconceivable in this media-driven age that we should not be able to put a face to a name as well known as Banksy's. Not surprisingly, people have rushed to play "Who's Banksy?" and the media have been full of the wildest speculation. There have been interviews with former classmates, friends, associates of the family, policemen, all with something to say about the mysterious artist and eager to share it, and the press has been quick to oblige, printing every scrap of information it can lay its hands on.

In 2010 Banksy released a film called *Exit Through the Gift Shop*. He not only made the documentary, he also appears in it. He does so, however, with his face hidden and his voice muffled, and anyone hoping to learn a little more about him will find themselves disappointed: it was a deliberated prank and revealed nothing about the maker's identity. Instead of saying anything about Banksy, it charts the career of somebody entirely different: a Frenchman by the name of Thierry Guetta, who reputedly tricked his way to fame and riches as an artist by jumping on the bandwagon of street art. It's impossible tell truth from fiction in the film, with the result that the mystery simply deepens. Some people even come away convinced that the mysterious Thierry Guetta is none other than Banksy himself.

Meanwhile, Banksy continues to be more and more sought after and collectors are ravenous for new works. It seems anonymity may be the key to success.

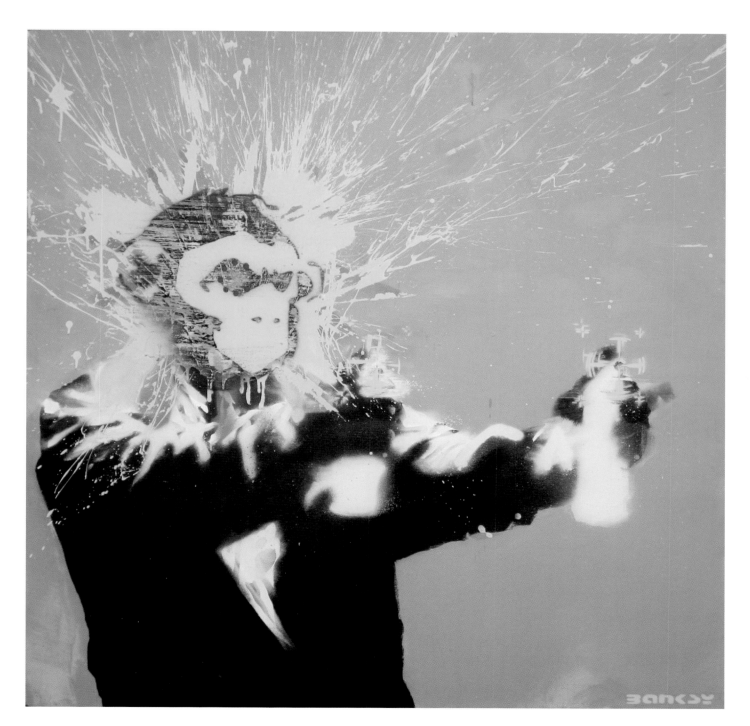

CREATION

ecause of their ability to create, artists have often been seen as
possessing powers bordering on the supernatural. All over the world
s and legends have grown up crediting painters and sculptors with
d capabilities. One of the most famous is probably the Ancient Greek
of Pygmalion, a sculptor who could not bear the idea of marriage to
re mortal and so decided to carve the ideal woman for himself
ad. The figure was so beautiful and perfectly formed that she seemed
. Pygmalion fell into the trap he had carved himself: he fell in love
the statue and began to pine away at the thought that her ivory flesh
d never be anything but cold and inanimate. Then, suddenly, Galatea
an to come to life…

r legends emphasize the respected and privileged position artists
yed because of their creative powers. Alexander the Great, for instance,
id to have held Apelles in such high regard that he knelt down to pick
paintbrush for him, while François I is supposed to have admired
nardo da Vinci to such an extent that he had his last breath collected
brought to him. The idea that artists have special and mysterious
ers has been carried down through the centuries. In the late nineteenth
early twentieth centuries, for example, it was manifest in the work of
tualist artists such as Fleury Joseph Crépin and Augustin Lesage (page
, who received instructions on how to paint "from beyond the grave."
a more down to earth note, there is often speculation about just how
works can have been made, particularly when they belong to a time
is distant from our own. They are so staggering that we can scarcely
it the idea that the pyramids were built in Ancient Egypt (page 88) or
huge and intricate patterns were drawn in the sands of the Nazca
rt (page 92). What tools can they have used and how many men

must it have taken to produce works on this scale? We find ourselves wondering if these people did not have special abilities that are no longer available to us today.

Another consideration when it comes to thinking about how works are made is that of context. The artist is often the only person who knows all the facts surrounding the creation of a work and could tell us for whom it was made, what special requirements there may have been, and how exactly it was produced. The farther removed a work is from us in time the more confused the tracks become and the harder it is to be sure of anything. In some cases, a picture which initially seems to be perplexing can quickly become clear when we understand the context, as is true of *The Coronation of Napoleon* by David (page 112). Once we know that the painter was working under the Emperor's orders, the picture makes complete sense and there is an explanation for all the "inaccuracies."

Other cases are less obvious, however. Luckily, modern scientific techniques such as radiography can sometimes come to our aid by revealing hidden aspects of a canvas, such as significant areas of repainting. These artistic "second thoughts" can reveal some interesting secrets. X-rays have revealed, for instance, that Francisco de Goya's famous painting *Time and the Old Women* (c. 1808–1812, Musée des Beaux-Arts, Lille, France) was painted over another picture, which tells us that the artist was hard-pressed for materials at the time. But not all revelations are quite as straightforward as this. It's not nearly so clear why Vélazquez decided to repaint an entire section of *Las Meninas* (page 104). The truth is that even when it comes to artists about whom we know a great deal—our contemporaries mainly—there will always be an element of mystery to the process of creation.

THE ART
OF MAGIC

Almost every legendary fictional adventurer from Tintin to Indiana Jones has soon or later succumbed to the allure of Ancient Egypt and followed in the footsteps of the real explorers and academics on whom they are often based. Egypt seems to hold secrets that are beyond us and generations of Western scholars from Herodotus to Jean-François Champollion and Howard Carter, who discovered the tomb of Tutankhamun, have been drawn to Egypt, hoping to unlock the mysteries of the civilization of the Pharaohs.

The myths surrounding Ancient Egypt are nothing new. They go back to the days of Ancient Egypt itself, whose inhabitants believed that their mummified dead could interfere in the lives of the living and that magic was a form of knowledge like any other. The Ancient Greeks, to whom the West owes so much of its culture and traditions, were notoriously dismissive of most other civilizations as barbarians, yet not only did they not dismiss the Egyptians, they admired and looked up to them as authorities. So great was their respect for Egyptian sages that Greek scholars would happily travel to the shores of the Nile in order to bolster their theories with knowledge learned at their feet. Ancient Egypt was also regarded with widespread awe for the power of its magic, to the extent that the Egyptians were even credited by some with teaching Jesus how to perform miracles. Egyptian art and monuments were not just beautiful, they were imbued with a spiritual force designed to give them tangible powers.

This is almost certainly why Ancient Egypt has long aroused keen interest and why it still generates all kinds of fabulous stories today. One such is that the Sphinx and the pyramids of Cheops, Chephren, and Mycerinus are far too extraordinary to have been built in the reign of the Pharaohs, somewhere between roughly 2650 and 2450 BC, the period known as the Fourth Dynasty. Surely the Egyptians must have had help to build them from the likes of scholars from the lost city of Atlantis, extra-terrestrials, gods. In fact, there was no need for any such intervention by higher beings, as archeologists have discovered: they have unearthed traces of brick-built ramps used to move blocks of stone. Only a rich, well-organized civilization with a powerful leader at its head could have mustered and mobilized enough manpower to build the pyramids. Contrary to popular belief, it was not slaves but successive waves of the Egyptian people who worked to raise these monuments to their Pharaohs. The gigantic Sphinx was made for Cheops and is the oldest-known representation of the hybrid creature. At 73 meters long and 20 meters high, it's the very incarnation of royal power. Another legend states that it was Napoleon who broke off the nose of the Sphinx. In fact, it was a fanatical Sufi Muslim in the fourteenth century, who wanted to mutilate what the Arabs call the "Father of Terror." Egypt is a land of legends: experts may dismiss most of the myths that have grown up in the course of its long history, but it remains a place where fiction and reality, magic and wisdom, seem inextricably intertwined.

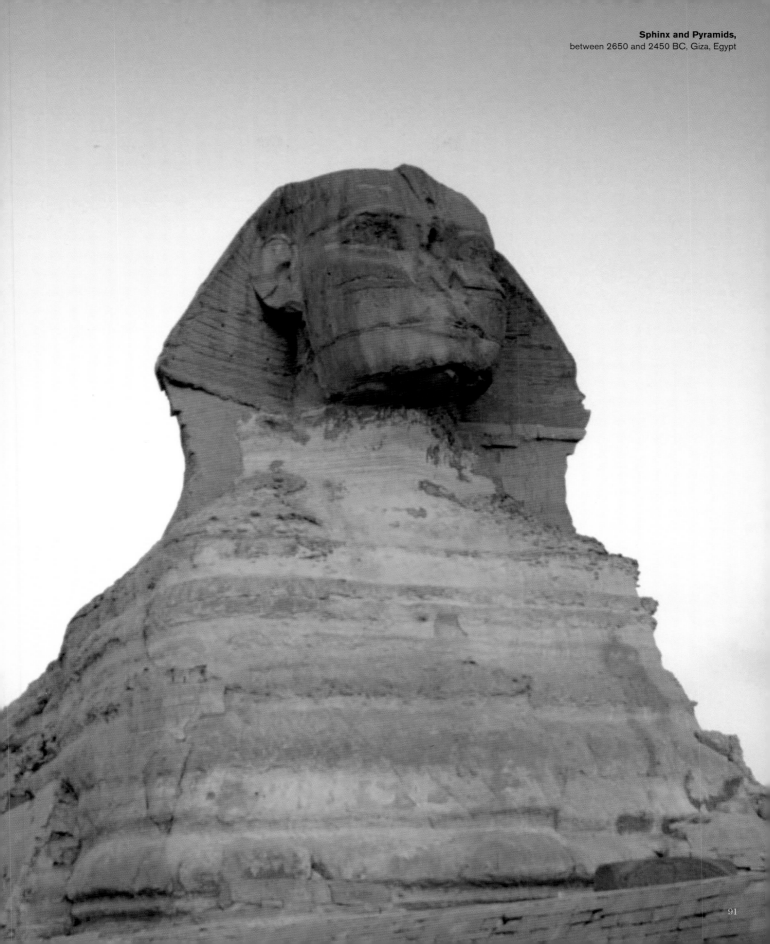

DECIPHERING GEOGLYPHS IN THE DESERT

The opening up of commercial flights over Peru in the 1920s brought with it an extraordinary discovery: visible only from the air were large ancient drawings of animals, plants, and geometric forms spread out over an area of 350 square kilometers. Since then, academics and keen amateurs have constructed countless theories to explain these huge geoglyphs.

Who were the Nazcas, why did they disappear, and, more particularly, why and how did they manage to create these gigantic works? Recent excavations by teams of archeologists have given us a little more insight into the history of these people who managed to establish a culture in one of the most arid regions in the world. The Nazcas came to the south-west of Peru around 200 BC and settled on the shores of the rivers that ran down from the Andes. Before them, the area was inhabited by the Paracas and it was they who first started carving designs into the landscape, cutting huge anthropomorphic figures into the hillside visible from the plain.

What distinguishes the Nazca Lines from earlier carvings is that they seem to defy understanding on many levels. The animal, plant and geometric shapes are all drawn with a single continuous line but appear to be visible in their entirety only from the air. Some theorists, bizarrely, have deduced from this that the Nazcas must have had access to some form of hot-air balloons that would have allowed them to look down on the shapes from above in order to be able draw them so skillfully. Others have deduced that the lines must have been made with the help of a higher or even extra-terrestrial civilization, and that they are in fact runways or markers for spaceships.

More plausibly, experts have conjectured that they might represent some form of astronomic calendar, or, more recently, following the discovery of altars at the ends of some of the shapes, that the lines mark out ceremonial routes. It was a culture dependent on a capricious climate, subject to frequent droughts, and may well have practiced various rites, including human sacrifice, designed to secure the goodwill of the gods of the mountains and springs. The lines would have acted as processional paths visible to the population from a number of different observation points.

As for how they were made, it seems in the end that the process might have been fairly simple. All that was needed was for an initial design to be drawn on a grid, for that grid then to be scaled up and marked out on the ground, and finally for the design to be cut into the ground by scraping away the surface cover of dark pebbles to reveal the sand beneath.

We will never be entirely sure what really motivated the Nazcas or how they set about creating their lines, but we can do our best to hazard a few credible suggestions from our own vantage point many centuries on.

Nazca Lines, "Condor," c. 200 BC –500 AD, 136 m long, UNESCO World Heritage Site, Peru

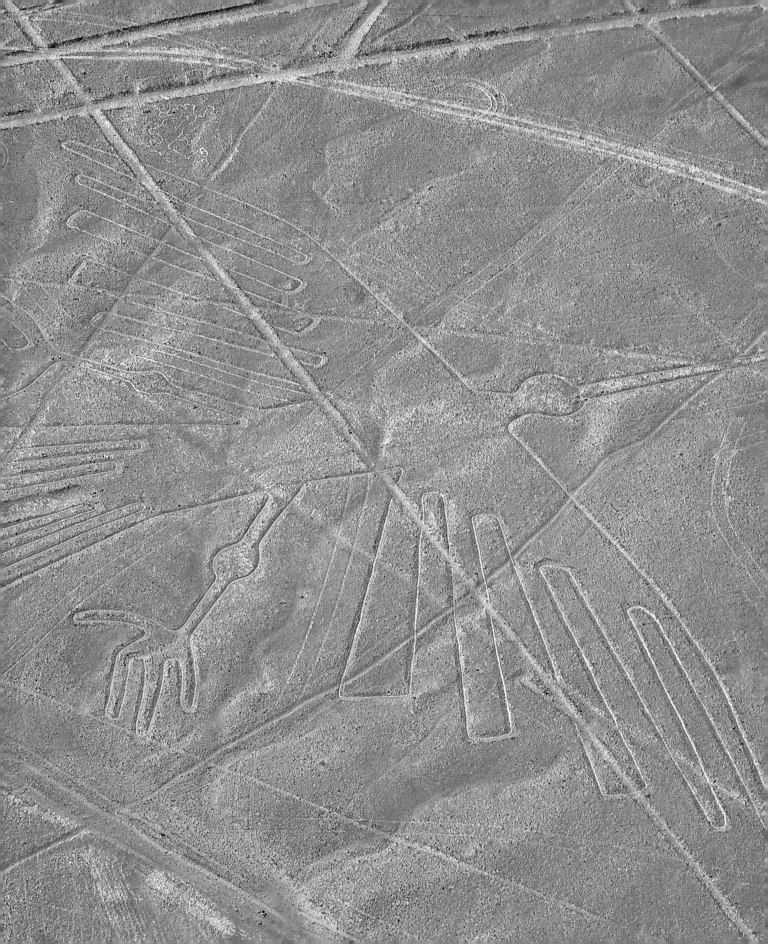

BETWEEN TWO WORLDS

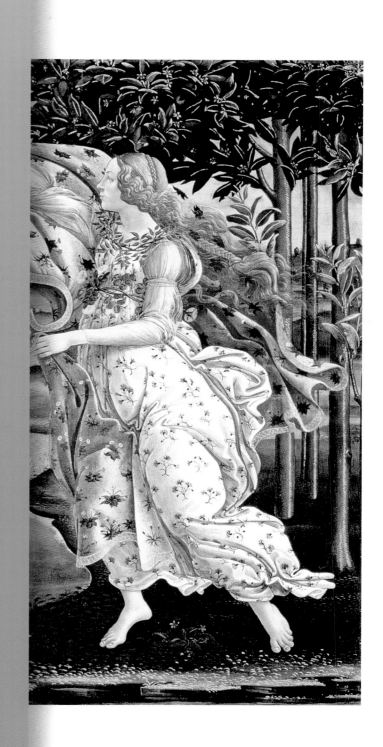

Sandro Botticelli was at the height of his fame in the 1480s. He was under the patronage of the Medici, Florence's ruling family, and painted one of his most famous pictures, an entrancing picture of Venus rising delicately above of the waves encircled by flowers. But beneath its aesthetically accomplished and polished surface lies a disconcerting mixture of styles and conventions.

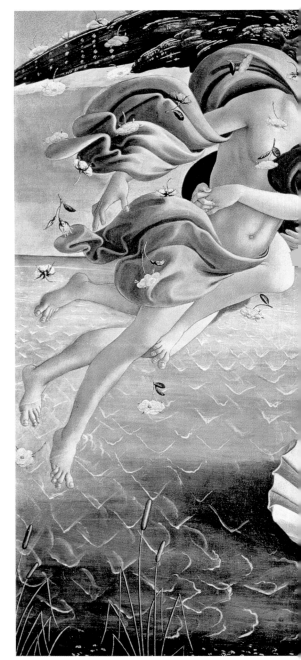

In Renaissance Florence, almost all art was confined to religious subjects. Although he was devout, Botticelli painted four large pictures of secular subjects, including *The Birth of Venus*. Like *Spring* (or *Primavera*, Uffizi Gallery, Florence) another large secular allegory, *The Birth of Venus* was probably commissioned by Lorenzo di Pierfrancesco de' Medici.

In it Botticelli takes up the myth of Venus Anadyomene (literally "Venus rising from the sea"), which describes how the goddess of Love and Beauty was born from out of the waves. Botticelli depicts her completely naked, being blown towards the shore on a huge shell by the god Zephyr, who appears on her right with his wife Chloris. To her left, one of the Hours waits for her to reach the shore, a red cloak at the ready with which to cover her.

We have become so used to seeing the picture that we tend not to look at it in anything but purely visual terms. Botticelli's Venus is far more complex than she appears, however. To appreciate it more fully, we need to imagine the Florentine art scene in 1485. Botticelli's work would have been strongly shaped by the influential Medici family, who set the fashion in art and scholarship. As a result, he would have done as directed by the philosopher and mystic Marsilo Ficino and sought to demonstrate a seamless continuity between classical culture and Christianity by providing a symbolic reading of the profane myth. This would have led him to look to classical artists for inspiration, and so to depict Venus naked—naked subjects were rare at the time.

Botticelli's version differs from those of his Greek and Roman predecessors in many respects, however. Most notably, perhaps, he does not use classical rules of proportion. He also paid little attention to the principles of perspective, despite the fact that these were an invention of the Italian Renaissance. What does he do then? He takes hold of a classical myth and reworks in a way that suits the tastes of his patrons. The Medici were keen on medieval tapestry, which is notable for its lack of depth, and for silver and gold work, which entailed a very crisp and accurate form of drawing, both of which are in evidence here. Also in evidence, however, are a sensuality, bustle and movement that are typical of the Renaissance. What we have, then, is a disconcerting mix of artistic styles and influences, part Christian, part pagan.

SANDRO BOTTICELLI (1445–1510),
The Birth of Venus, c. 1485,
egg tempera on linen, 184.5 × 285.5 cm, Galleria degli Uffizi, Florence, Italy

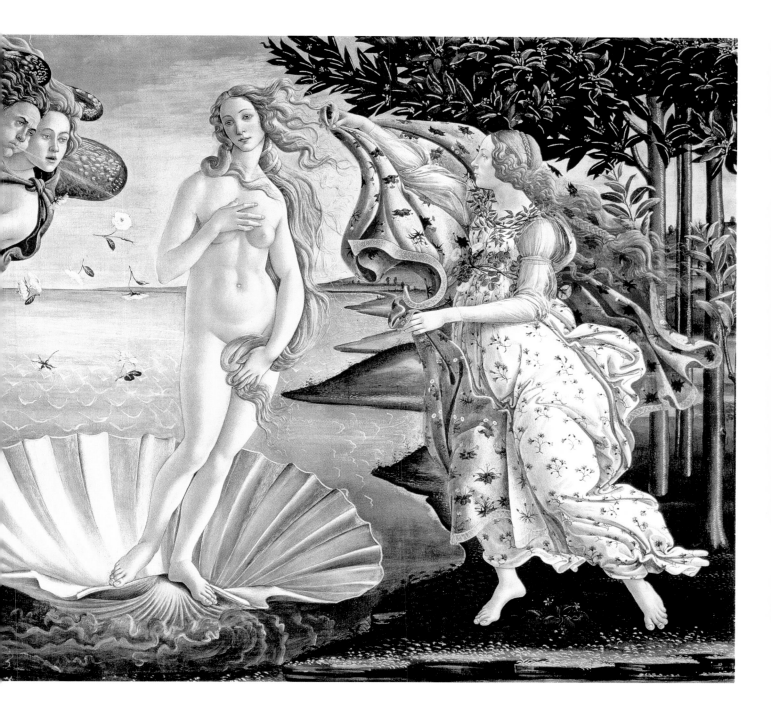

The Ceiling of the Sistine Chapel

RELUCTANT GENIUS

Michelangelo was first and foremost a sculptor, yet it was to him that Pope Julius II entrusted the project of decorating the Sistine Chapel. He did so on the advice of Michelangelo's archenemy Bramante, who wanted to see him humiliated and exposed as inadequate for the task. Stung to the quick, Michelangelo accepted this incredible challenge, and managed to finish the ceiling in four years, in spite of countless difficulties. This is hard to credit, particularly when we know that the recent restoration project took nine years. Myths about the sculptor began to proliferate almost the moment the prodigious work was finished.

Michelangelo began work on the site immediately the contract was signed in May 1508. There were many who thought that he would not be able to complete the project. He certainly had to overcome considerable difficulties. The shape of the vault required a great command of drawing and foreshortening, and Michelangelo, it should be remembered, was not a painter by profession and lacked experience in this area. Moreover, fresco painting was technically complicated: the plaster had to be painted while it was fresh and this required meticulous preparation and deft execution. Michelangelo's lack of practical experience delayed his progress, much to the displeasure of Julius II, who harried him continually. Michelangelo would not be pressured, however; instead, and doubtless because he was unhappy with his initial efforts, he took a hammer and chisel and destroyed several weeks' work. A few months after this he became completely disheartened when damp and salt crystals rose to the surface of areas he had already painted, causing catastrophic damage to the frescoes. Michelangelo complained to the pope that he had warned him that painting was not his profession and told him he wanted to abandon the project. Promptly employing an architect to sort out the problem, the Pope then instructed the unwilling Michelangelo to go back to work.

In June 1509, Michelangelo wrote to his father: "I am not happy and in fairly bad health, faced with this enormous task, with nobody to help me…"

Writing in the sixteenth century, the biographer Giorgio Vasari reported that Michelangelo turned against his assistants and decided to finish the project alone. But we now know that this is untrue: he had a team working with him throughout the project. The same goes for the story that he painted the ceiling flat on his back on scaffolding, paint dripping into his eyes. Michelangelo himself designed the scaffolding so that he could work standing up, although he did have to work with his head tipped back and his arm lifted, so that paint dripped onto the top of his head. It was not an easy position and Michelangelo found both it, and the constant pressure, hard to bear, and in his letters complained bitterly of health problems. But he did manage to finish the ceiling, and produced something so remarkable that it continues to astonish and to be the source of endless stories regarding his personality and genius.

MICHELANGELO BUONARROTI, known as MICHELANGELO (1475–1564),
Ceiling and Lunettes of the Sistine Chapel, 1508–1512,
fresco, 1,300 × 3,600 cm, Vatican Museums, Vatican, Italy

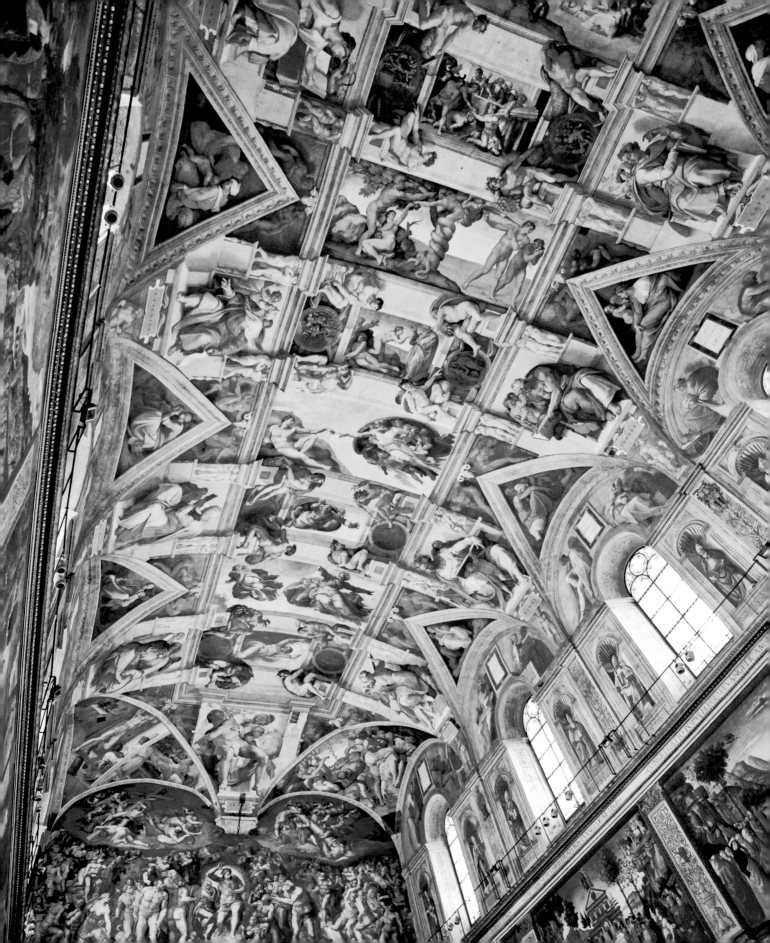

THE VANISHING GOLD RING

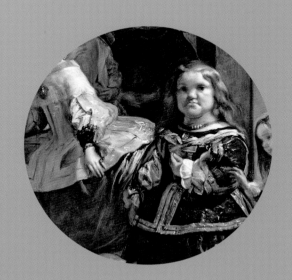

This painting is extraordinarily original and there are all sorts of stories to be discovered behind both the unusual setting in which the royal family is depicted and Vélazquez's significant reworking of the picture. While it's widely admired, the picture is often misunderstood, and though a great deal is known both about the people portrayed and about Vélazquez's life, the picture itself remains enigmatic.

Vélazquez was official painter to the court of Spain and this picture shows the young five-year-old Infanta suddenly appearing in his studio, surrounded by her retinue, including her maids of honor, known as *meninas*. The scenario seems straightforward enough at first sight: the girl has come to see her parents, the king and queen of Spain, as they pose for Vélazquez, who is busy painting them. Even this is not entirely simple to grasp, however. To get this far, we have to make out the royal couple in the faint reflection in the mirror, a highly original device on Vélazquez's part that could not have been adopted without their consent.

The setting allows Vélazquez to portray the ruling family in a way that would not be possible in an official portrait. The scene is purely fictitious, however, and does not correspond to a real episode in the lives of the royal family. Crowned heads of state never took the time to pose: their portraits were painted from quick preparatory sketches. This is where we begin to get lost: What was Vélazquez trying to show here?

X-ray examination of the painting in the 1990s revealed substantial reworking that appreciably alters its meaning. It's impossible to know for certain just how far this reworking extended, but it seems likely that the whole of the left side—the side with the self-portrait—was repainted. The question is, Why? Manuela Mena Marqués, then curator at the Prado museum, put forward an interesting theory based on the fact that at the time the picture was originally painted, the Infanta Margaret Theresa was next in line to the throne. This large-scale painting would thus have started out as an official picture marking her status as heiress to the crown. The dog would have represented loyalty and the painted-out gold ring that the dwarf originally held would have symbolized obedience. But in 1657 Philip Prospero was born and the boy superseded her as heir to the crown. Vélazquez repainted the picture in 1659, making it no longer an official picture of the heiress to the crown of Spain, but a private painting of a family scene that was to be relegated to the King's study in his summer palace. Vélazquez not only painted out the gold ring, he also added the insignia of the Legion of Honor, the Santiago Cross that the King had awarded him in the interim. The self-portrait is also thought by some to date from this time and not to have been included in the original official version.

Vélazquez almost certainly saw the reflection in the mirror as a way of flattering the King, suggesting as it does that the King was omnipresent and that nothing escaped his gaze or took place without his consent. Only the royal couple, after all, and the viewer, can see all the figures in the picture. That said, it's difficult to say quite why Vélazquez adopted such a complex and original composition—unless, of course, it was purely a whim, an artistic *jeu d'esprit* on his part.

DIEGO DE SILVA VÉLAZQUEZ (1599–1660),
The Family of Philip IV, also known as **Las Meninas,** c. 1656,
oil on canvas, 318 × 276 cm, Museo Nacional del Prado, Madrid, Spain

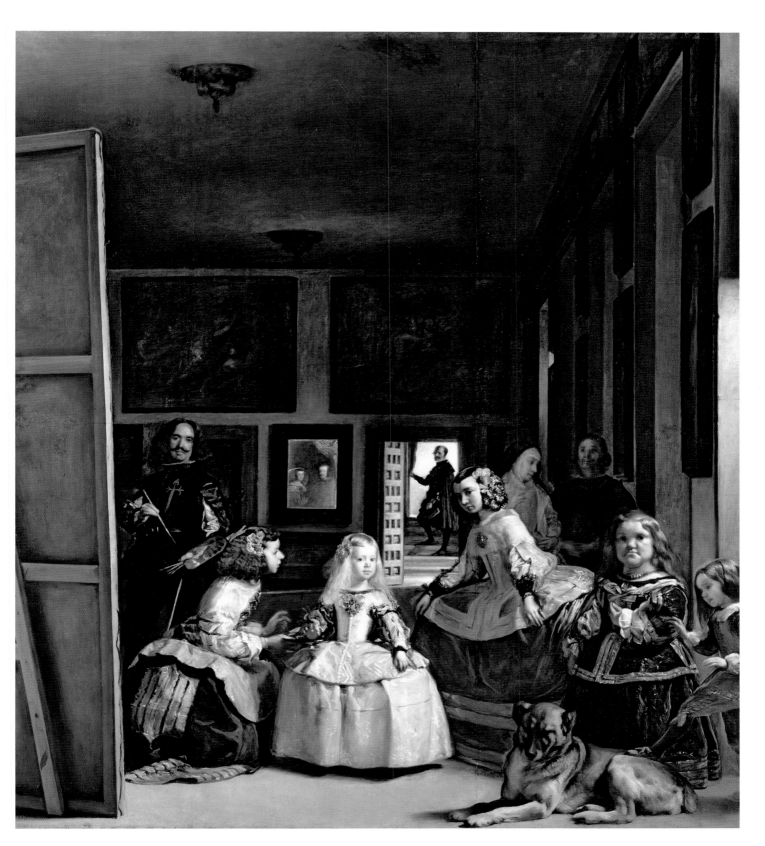

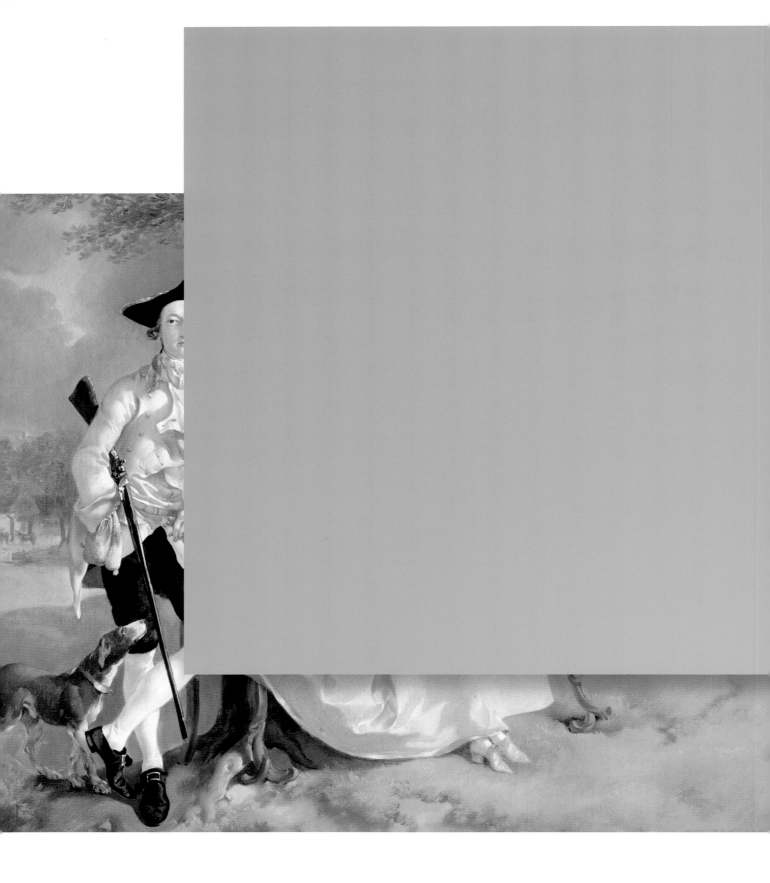

Mr and Mrs Andrews

A MYSTERIOUS
BLANK

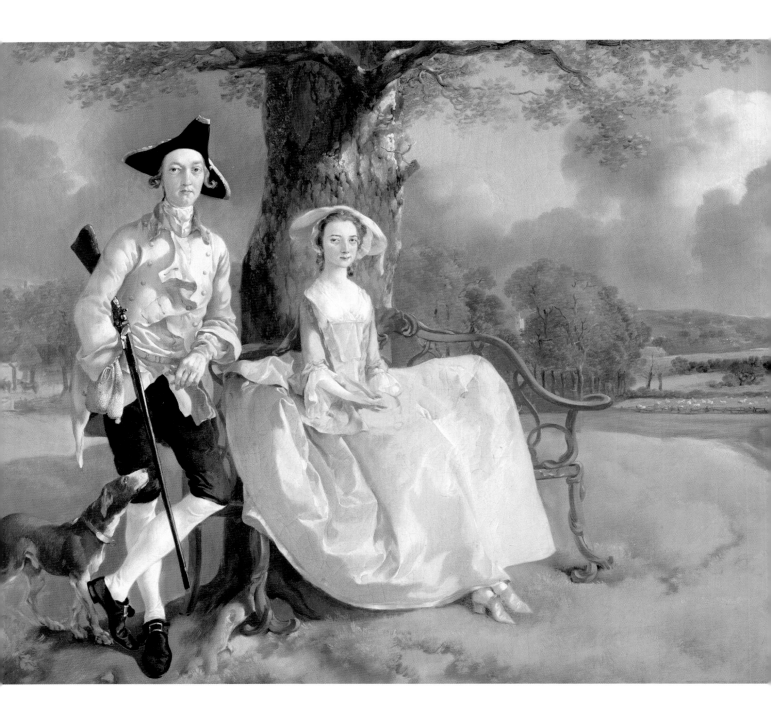

THOMAS GAINSBOROUGH (1727–1788),
Mr and Mrs Andrews, c. 1750,
oil on canvas, 69.8 × 119.4 cm, National Gallery, London, United Kingdom

There has been a great deal of comment on the abnormally large space given over to the landscape in *Mr and Mrs Andrews*. But there is another shocking aspect of the painting that cries out for at least as much if not more comment, and that is the blank patch on the wife's dress. How can either the painter or the sitters possibly have been happy with an unfinished picture?

This carefully constructed painting illustrates the success of the Andrews couple. Although they are set to one side, the elegant husband and wife occupy a commanding position in the forefront of the picture. The picture stresses the success not just of their marriage but of the economic management of their estate, presenting both in a favorable light. Where the landscape in many portraits tends to be largely decorative, here it's recorded in every fertile detail, demonstrating Mr Andrews' judicious management of it.

It's difficult to understand how such a meticulously detailed painting could have been delivered partly unfinished, yet this is what happened: not only was it delivered to the Andrews, but it remained in the family's possession until 1960.

One popular theory is that the woman was holding a pheasant that her husband had killed, but this does not really explain why the painter should have opted to leave a patch blank. There is a suggestion that the bird could have been interpreted as a sexual symbol and might therefore have been left out for this reason, yet birds have been depicted in countless other pictures without anyone being offended, so this theory does not seem very plausible. But it does highlight one point that may be of relevance: the blank patch lies directly over the woman's pubis. This has led some to suppose that Gainsborough had a terror of female sexuality and left the picture unfinished as a way in effect of "unsexing" Mrs Andrews.

Another popular explanation is that the painting was left in this unfinished state so that a child could be added as and when he or she came along, tangible evidence of the consummation of the couple's union and a further symbol of its success. The theory is not in the least persuasive: in the first place, a child could easily have been added to a finished picture, and in the second, the Andrews' son was born before the picture was finished.

Ultimately, all that we can say is that it's remarkable that Gainsborough managed to persuade the Andrews to accept the painting in its unfinished state. Whatever reason he gave, it must have been compelling.

BETWEEN THE REAL AND THE IDEAL

On 2 December 1804 Napoleon Bonaparte was crowned emperor in the cathedral of Notre-Dame in Paris. It was no ordinary ceremony: in an extraordinary gesture, Napoleon has already pushed past the Pope, seized the crown and placed it on his head himself. This remarkable event was to become forever associated in most people's minds with Jacques-Louis David's famous painting of the ceremony. Yet David's depiction is far from being an accurate record of the scene. Embedded within in are a good many historical "inaccuracies" which smack more of propaganda than of art.

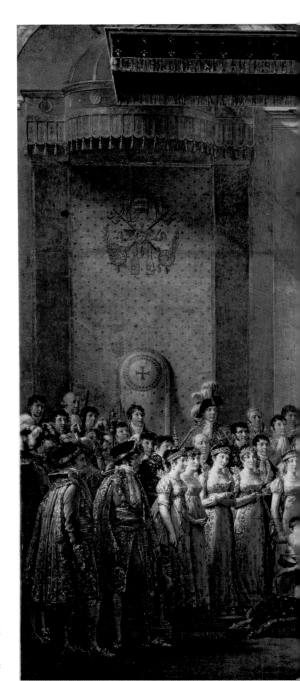

David was appointed official painter to the Emperor in 1804 and given the task of immortalizing for posterity four key moments in the coronation ceremony, including the actual crowning. Although David described himself as "a true and accurate painter through and through," when he came to paint *The Coronation of Napoleon* he wavered between realism and idealization.

Anyone who has a keen sense of history is bound to be surprised by David's depiction of the event. Immediately striking is the fact the picture does not tally with the title the painter gave it. The ceremony is well advanced and the main action has already taken place: Napoleon has already proclaimed himself emperor and is now preparing to crown his wife, Josephine. It's clear from David's preparatory sketches that he originally intended to show Napoleon crowning himself, but he evidently modified the scene, perhaps on the Emperor's orders.

Most striking of all is the fact that this ostensibly documentary group scene is not actually true to reality: the scene as portrayed did not take place. Of the 146 people who can be individually made out in the picture, half have been positively identified. Astonishingly, many of the people who are "present" in David's picture are known to have been absent from the ceremony. Sitting in the box immediately facing us, for instance, we see Madame Mère, the Emperor's mother, who disapproved of the ceremony and did not attend. Also visible is Cardinal Caprara, who is shown on the right of Pope Pius VII when in reality he was ill that day and stayed away. David even took the liberty of including himself in the box above Madame Mère, and went so far as to include not only his own wife and two children, but also his assistant Rouget, his friend Antoine Mongez, and even his master, the painter Joseph-Marie Vien. These were not the only "adjustments" he made: Josephine was made younger for the occasion, and Notre-Dame made smaller so that the figures would look more imposing.

Although he was an eyewitness to the ceremony, David found himself torn between depicting the event as it happened and representing it a way that would lend legitimacy to the emperor's arrogation of power, as Napoleon I had ordered him to. When it came to it, what David produced was a piece of propaganda in the service of the Empire.

JACQUES-LOUIS DAVID (1748–1825),
Coronation of Emperor Napoleon I and the Crowning of Josephine in the Cathedral of Notre-Dame in Paris, 2 December 1804, also known as **The Coronation of Napoleon,**
1806–1807, oil on canvas, 621 × 979 cm, Musée du Louvre, Paris, France

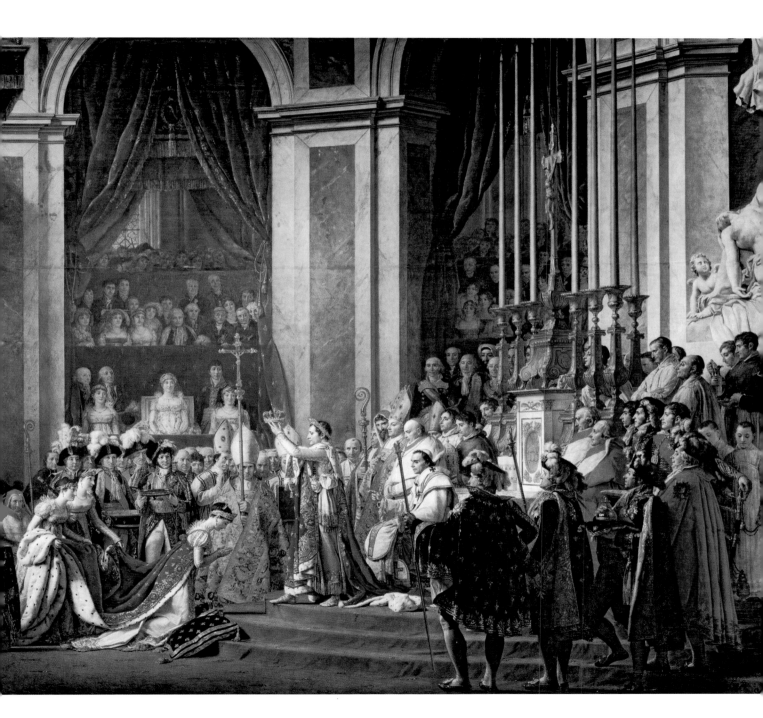

"IS THERE ANYONE THERE?"

During the early years of the twentieth century a French miner suddenly decided to start painting, saying that a voice told him to do so in the darkness of a mine. This may sound like an improbable tale, but it's what apparently happened to Augustin Lesage, who subsequently became famous and is now considered one of the masters of "art brut."

Spiritualist art, a term which describes works created under instruction from the "spirit world" by artists who act as mediums, took root in the mystical climate of the late nineteenth century. More often than not, these mediums were already artists before they started hearing spirit voices. More rarely, there are cases of extraordinary transformations, such as that of Augustin Lesage, who relatively late in life went from being an unknown miner to being a famous artist. In 1911 or 1912, when he was in his mid thirties, something happened which was to turn his life upside down. "I was in the mine, in a very remote gallery, working on my own in a small fifty centimeter cut [...] All of a sudden, I heard voices talking to me. [...] I was scared, my hair stood on end [...] I heard: 'Don't be afraid, we're right by you, one day you'll be a painter.'" Terrified though he was, on his friends' advice Lesage let himself be won over to spiritualism. He took part in occult séances and at one of these the voices made themselves heard again: "First of all, we are going to write out the names of the brushes and colors that you are going to go and get from Monsieur Poriche at Lillers…" Lesage obeyed, and also ordered a canvas. There was a misunderstanding and the canvas that was delivered was huge, measuring three meters square. As he prepared to cut it up into smaller pieces, the spirits intervened, saying: "Don't cut the canvas up. It will paint itself." Lesage started in one corner and spent every evening and every Sunday for over a year "filling in" the canvas mechanically with designs, meekly following the instructions he heard. Painting this first picture brought him great relief: he had found his way. He continued to paint whatever the spirits of the dead told him to, and even signed several works in their names, including

"I have never had any idea of a how a painting will turn out before starting it. I have never had a an image of what the whole picture will look like." Augustin Lesage

Leonardo da Vinci, Marius of Tyana (a distorted form of the name of the classical painter Apollonius of Tyana), and Marie, his sister, who had died at the age of three. Even though there were several different "phases" to his career, his style remained relatively unchanging: he would create a complicated mass of architectural blocks out of tiny geometric shapes, usually round or oval. Remarkably, his work is always symmetrical, even though he never stood back to look at his work as he painted.

When he died in 1954, this man whom nothing had in any way predestined for painting left behind him some 800 paintings. His work fascinated people because of its originality and richness of expression. Even the most skeptical were forced to concede that there was something beyond the realm of simple human will directing the destiny of this obscure miner's son. There is no doubt that Lesage heard a voice speaking to him in the depths of the mine—but was it not perhaps his own subconscious, urging him to escape his arduous life?

AUGUSTIN LESAGE (1876–1954),
Composition, 1925, 212 × 144 cm,
Musée de Béthune, Dépôt de l'Institut Métapsychique International, France

NEVER ENTIRELY BLACK OR WHITE

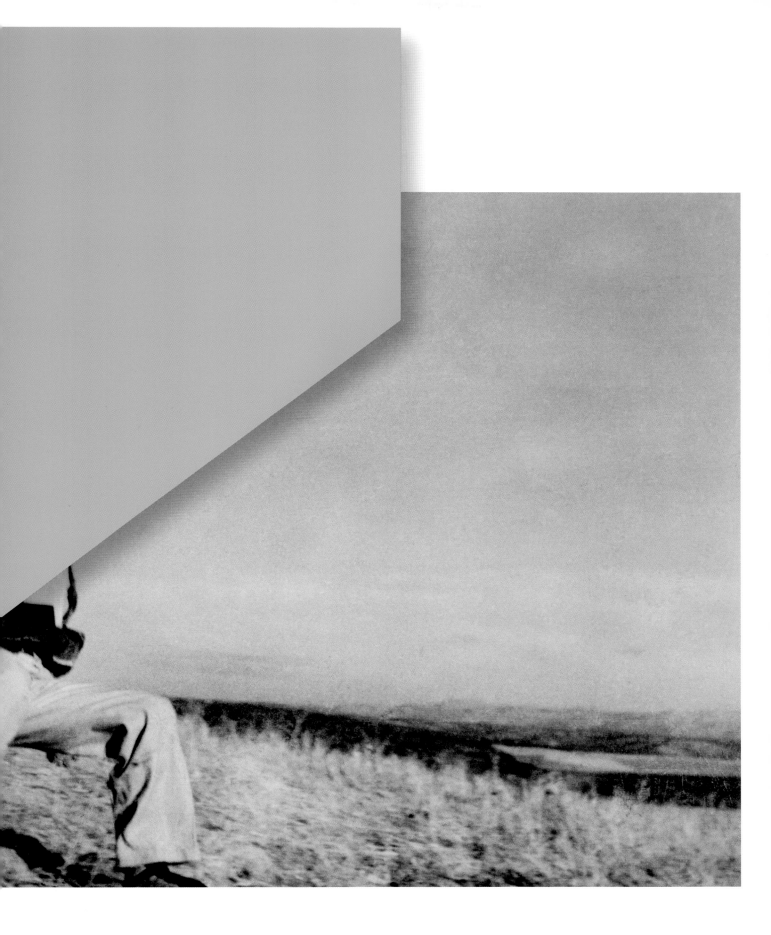

In 1936 Robert Capa sent back a shocking picture from the front that was to become a defining image of the Spanish Civil War: it shows a Republican soldier fatally hit and falling. It was a photograph that seemed too incredible to be true, and in the 1970s fierce debate erupted as doubts were raised over its authenticity.

Capa was barely twenty-two when he went off to cover the Spanish Civil War, the strap of his Leica over his shoulder. In 1936, near Cordoba, he took a shot which was to become famous all over the world. It was first published on 23 September 1936 in a special issue of the French magazine *Vu*, along with other shots taken the same day. *The Falling Soldier* immediately became an iconic image of the Spanish Civil War.

The suggestion that it was "staged" was first first made in 1975 by the journalist Philip Knightley, who argued that it was the product of an organized shoot in which a group of militiamen posed for the camera. He was backed up by experts, who pointed to the lack of any sign of impact from a bullet and declared that the pose of the falling man was "impossible." Robert's brother, Cornell Capa, came to his brother's defense, vehemently contending that it was obvious from its blurry quality that the photograph had to have been taken from life. Since then people have sided with one camp or the other and the debate continues unabated. Some have even suggested that the photograph was not taken by Capa at all, but by Gerda Taro, who was then his lover.

In 1996 the man in the photograph was tentatively identified as Federico Borrell Garcia, a Republican soldier. This identification was subsequently rejected in a documentary broadcast on Spanish television in 2007 entitled *La Sombra del iceberg* ("The Shadow of the Iceberg"), based on reports of Federico's death in the anarchist newspaper *Ruta Confederal* in October 1937, which describes it as taking place in quite different circumstances. So we still don't know the identity of the man.

Then in 2007 the International Center of Photography in New York put on an exhibition that included others in the series of photographs taken that same day by both Gerda and Capa. It is clear that they were not facing the enemy: some of the soldiers are shown sitting down, having a rest. Richard Whelan, curator of the Capa archives, suggests that, while the soldiers may well have been posing at the start, they were genuinely surprised by bullets in the middle of the shoot. He explains that "the truth is never entirely black or white. It is neither a photograph of a man pretending to have been shot, nor an image made during what we would normally consider the heat of battle. […] We will probably never know what actually happened on that hillside."

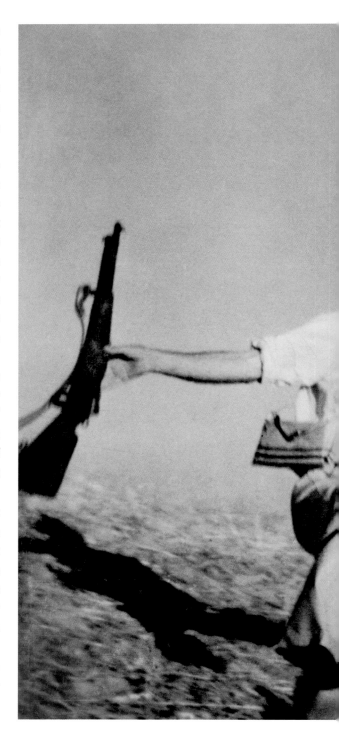

ROBERT CAPA (1913–1954),
The Falling Soldier, photograph taken on 5 September 1936,
at Cerro Muriano (Cordoba front), Spain

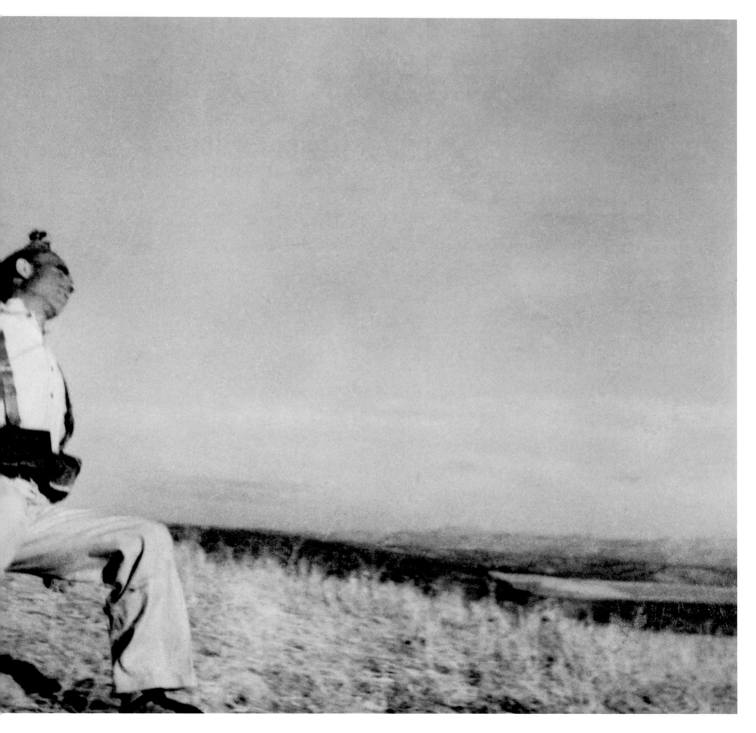

123

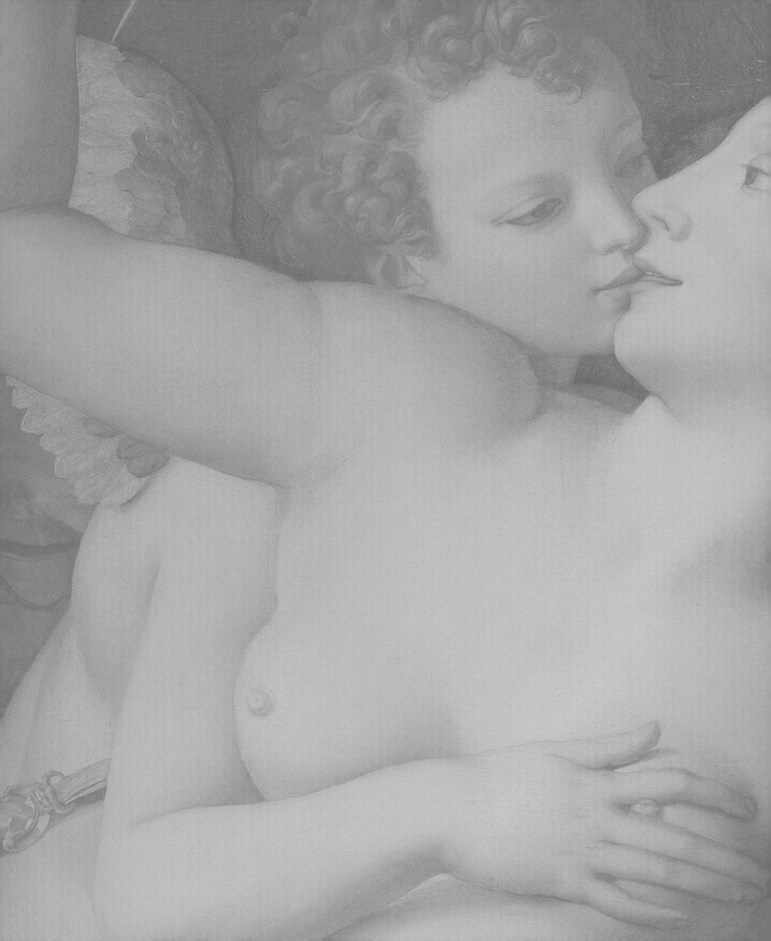

MEANING

Because they inevitably reflect particular periods with specific sets of beliefs and forms of knowledge, most works of art are broadly comprehensible to their contemporaries. It's rare for works of art to be deliberately enigmatic: pictures are generally designed to tell a story, offer an explanation or demonstration, or deliver precise visual information. They need to be legible. Art has not always been keen, however, as it generally is now, to become more popular and to be accessible to all. For a long time, particularly in the West, it was the province of the elite because they were the only people in a position to buy luxury goods and to have access to the culture and education needed to understand the subtle references art made.

In the Middle Ages, by contrast, works of art were aimed at the common people. The Church commissioned paintings of religious subjects in order to allow the illiterate populace to learn and understand the message of Christianity. To be effective, the images had to be eloquent and unambiguous. Images of Hell, for instance, had to make those who looked at them quake in their boots and deter them from sinning by graphically depicting terrifying tortures. There was no need for them to understand every reference and allusion in Bosch's confusing picture of Hell (page 140) to feel the full terror of the Devil and his depraved band of demons.

By the same token, they did not need to know the Bible inside out to feel the comfort of those beautiful, majestic, motherly Madonnas or to pity the sufferings of Christ on the cross.

At the other end of the scale, there are erudite works such as Dürer's *Melencolia I* (page 150) and Bronzino's *An Allegory with Venus and Cupid* (page 154) that were—and still are—the province of a learned and cultured few. Sometimes we have lost touch with a particular culture and so what was once legible is no longer so, as in the case of the drawings in the cave at Lascaux (page 128). Sometimes we need extensive knowledge of a period to read the clues in a picture and begin to understand who the figures in it are, what story is being told, and what message we are meant to find in it. Such difficulties of interpretation are compounded by the fact that there is no codification of symbols in Western painting and that they can often have different and even contrary meanings. A dog, for instance, can represent laziness (as in *Melencolia I*), faithfulness (as in *The Arnolfini Portrait*, page 132), or social status (as in *Mr and Mrs Andrews*, page 108).

However, some elements in a picture may have a purely aesthetic purpose or may be designed simply to enhance a sense of realism. Eager as we might be to explain and decipher everything, we need to guard against over-interpretation. The question is: Where do we draw the line?

BETWEEN LIFE AND DEATH

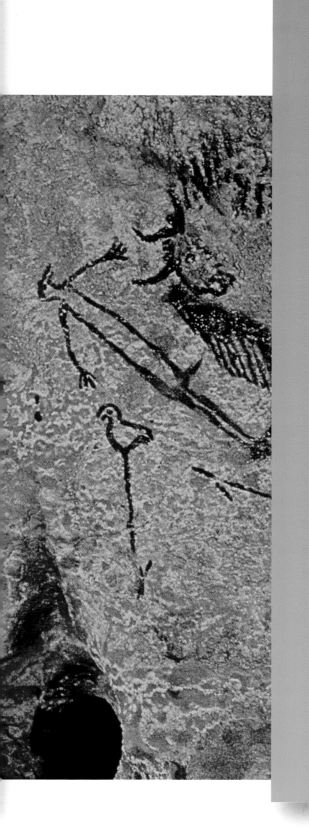

Prehistory covers the vast period that predated the emergence of writing and that produced only one remotely decipherable form of language: the language of art. Although increasingly seen by scholars as having a spiritual significance, prehistoric cave paintings continue to prove difficult to understand and raise a great many questions. Among the most mysterious are the extraordinary figures in the Well Scene in the cave at Lascaux in France, which date back to about 15,000 BC and are particularly remarkable because they include a being half man, half beast, exotic animals, and death.

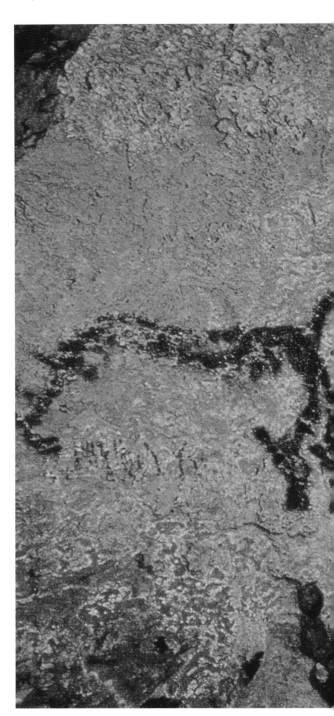

Discovered in a gallery set apart from the rest, the Well Scene at Lascaux is one of the strangest paintings in prehistoric art. It depicts three animals (a bird, a bison, and a rhinoceros) and, unusually, a human being.

The cave paintings at Lascaux date from the Paleolithic Age, when our ancestors were constantly on the move in search of food. Animals were vital to their survival and it's easy to see how profoundly important they would therefore have been to them, and why they are so common in cave paintings. What makes the particular painting in question so highly original and interesting is its narrative element. The scene is dominated by a fight to the death between an injured bison whose entrails are spilling out and a man knocked to the ground by the animal.

Confrontation is a recurring theme in cave painting. Generally speaking, however, it's the man who is shown triumphing over the animal, probably as part of a shamanistic ritual designed to secure a fruitful outcome to a hunt. What makes the Well Scene so mysterious is its apparently tragic outcome.

Representing a notable departure from the norm, it has posed numerous questions. Equally extraordinary is the figure of the man, with his schematic rectangular body and bird's head. Usually, a sharp-edged four-sided shape like this with an erect phallus symbolizes man's power and dominion over nature, in contrast to the sinuous lines with which the animals are delineated. So how is it that this virile man appears to be succumbing to his prey?

The idea of death is emphasized by the double presence of a bird. The man seems to have a bird's head and this links with the bird shown at his side. In prehistoric art, birds appear to represent the transition between life and death.

Separated from them by tens of thousands of years, we will never fully fathom the mysteries of our far distant ancestors of the Paleolithic age, but their paintings will continue to move us and offer tantalizing clues about their lives and beliefs.

Well Scene, c. 15,000 BC,
black pigment (manganese oxide), length of the bison: 103 cm,
cave at Lascaux, Montignac, France

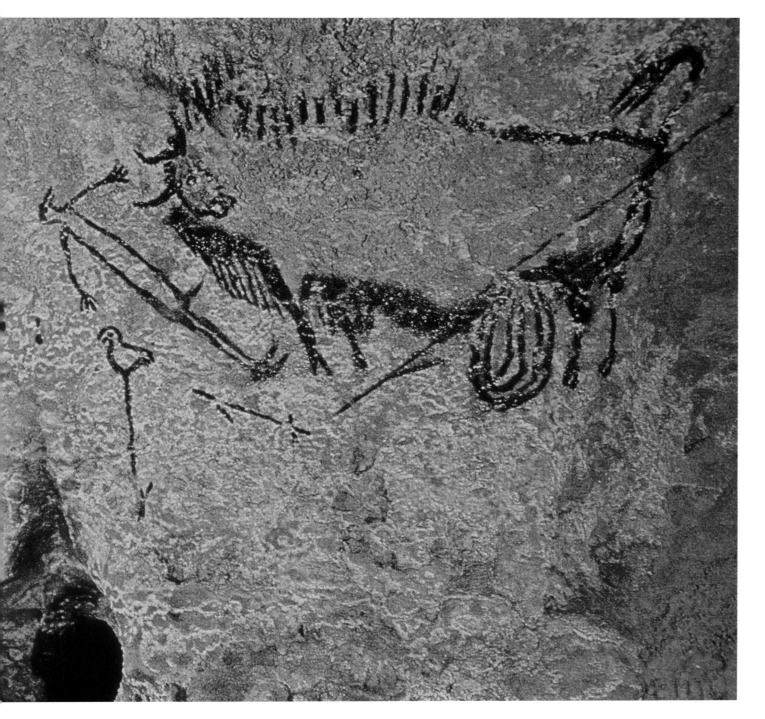

A STRANGE CEREMONY

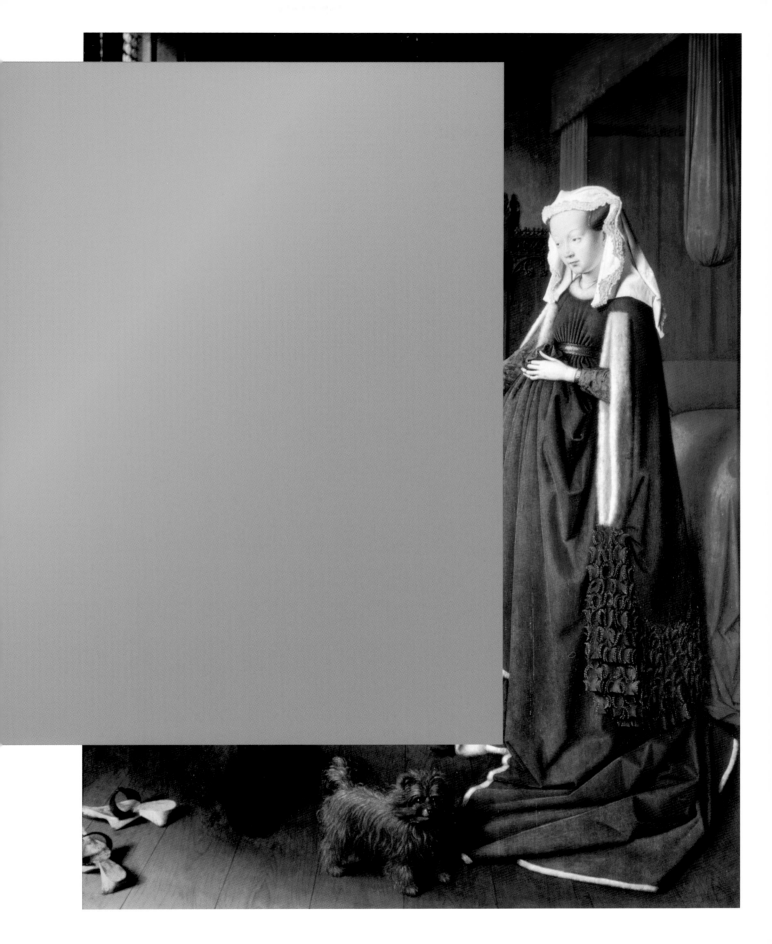

The best-known paintings are not always those that are best understood. *The Arnolfini Portrait* **is a case in point. Despite its popularity and the countless studies devoted to it, it remains enigmatic. Experts cannot agree on the most basic facts about the painting and continue to debate not just what the scene means but even who the protagonists are.**

The most popular theory about the picture derives from its title: it's commonly claimed that the central figures are Giovanni di Nicolao Arnolfini, a rich Italian merchant based in Bruges, and his wife, Giovanna Cenami. The scene is taken to be their wedding, and a number of details are cited in support of this interpretation. Most obviously, there is the gesture of the hands. This is closely followed by the choice of the bedroom as the setting, with its prominent red bed, and then the dog that symbolizes faithfulness and the single candlestick, emblematic of marriage. At that time, marriage ceremonies could be conducted between two people in private; all that was needed to confirm their legality was that two witnesses should be present to testify that a wedding had taken place. Here there are two witnesses to the scene in the shape of two men reflected in the mirror, one whom is the artist himself, if the Latin inscription above the reflection, "Johannes de eyck fuit hic. 1434" ("Jan van Eyck was here, 1434"), is anything to go by. Some people even maintain that the woman is pregnant, but this is probably an over-hasty deduction: the fullness and folds of her dress were simply the latest fashion of the day.

But this reading of *The Arnolfini Portrait* is not entirely convincing, not least because it does not account for the choice of subject: it was far from usual at the time to portray a ceremony of this kind in painting. Then there is the matter of the hands. It makes no sense that a man should give his left hand to his supposed betrothed: we all know that it's two right hands which have to be joined in marriage, so it's difficult to see how the way these two people are holding hands can be an illustration of it. Moreover, the picture only acquired the title on which the interpretation is based almost a century after it was painted, when it was listed in an inventory under the name of "one Arnoult Fin." Its popular tile, *The Arnolfini Marriage*, is based on nothing more than an inference.

It could of course be that the man is none other than van Eyck himself and the woman his wife, Margaret, which would give a whole new meaning to the inscription attesting to his presence. It's a theory to which the presence of the figure of Saint Margaret behind the wife lends support, or so its proponents maintain.

Interesting though it is, however, this theory has failed to supplant the popular one that it depicts a betrothal or marriage ceremony. There are still therefore suppositions on the meaning of this strange scene, which, after all, may perhaps not represent a married couple…

JAN VAN EYCK (c. 1395–1441),
The Arnolfini Portrait, also known as **The Arnolfini Marriage,** 1434,
oil on oak, 82.2 × 60 cm, National Gallery, London, United Kingdom

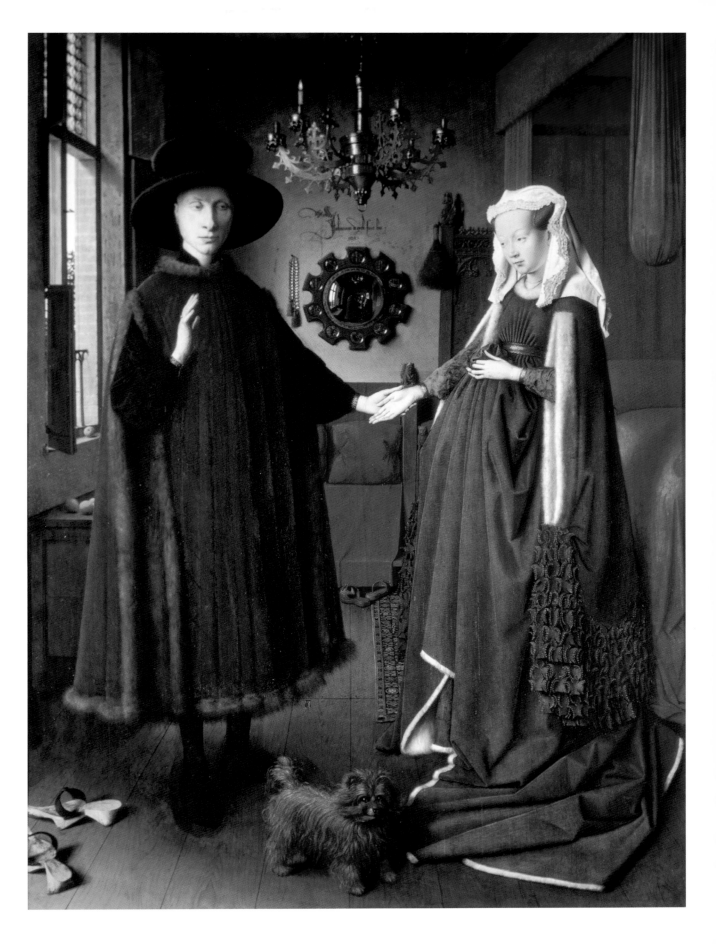

THE SECRETS OF A FORGOTTEN BEAUTY

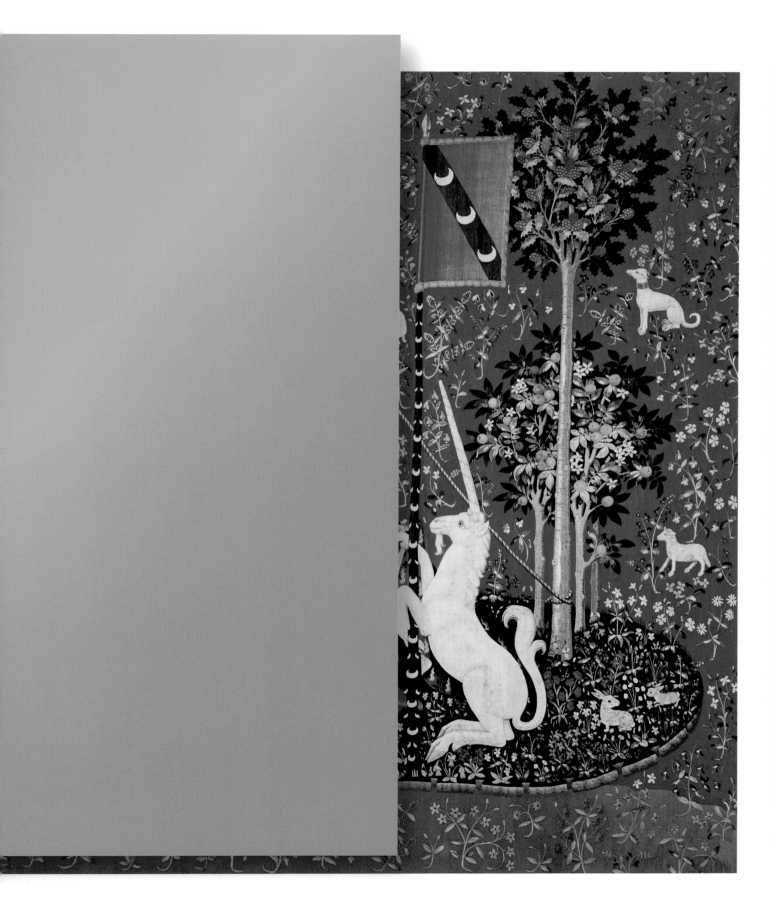

Since their rediscovery in the nineteenth century, *The Lady and the Unicorn* tapestries have continued to fascinate and intrigue. A beautiful, richly attired woman is flanked by mythical and exotic animals, a unicorn on one side and a lion and sometimes a monkey on the other. Experts are generally agreed on the likely meaning of five of the panels, but the sixth remains enigmatic. For the work to make sense, however, it has to be viewed as a whole and all six pieces taken into account—if indeed there were originally six, and not eight.

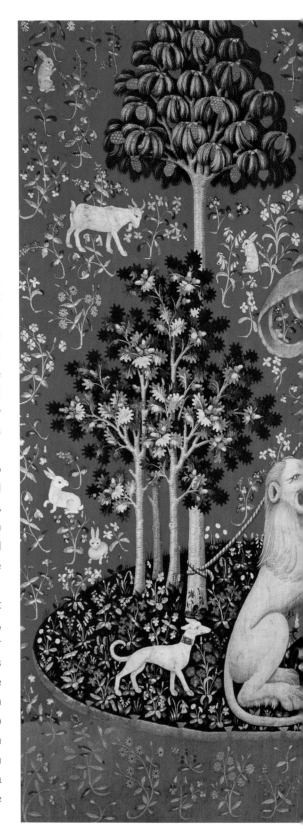

In 1841, his role as inspector general of ancient monuments led the French writer Prosper Mérimée to visit the Château of Boussac in the Creuse, central France. There he was immediately struck by a set of magnificent but unknown tapestries. Even in their neglected state, the hangings had a grace and strangeness that made him think they might be Oriental in origin, as he explained in a letter to Ludovic Vitet dated 18 July 1841: "There is something particular about these tapestries which makes one think […] they were made for the son of the Sultan. All six show a very beautiful woman […] richly dressed in a distinctly Oriental way." There is nothing to support this theory, however, any more than any of the many other curious and sometimes fantastical theories prompted by the panels.

It was thanks to another French writer that the Lady and the Unicorn was to become famous: George Sand was similarly fascinated by the tapestries and wrote about them both in an article and also in several of her fictional works. A keen observer, she was able to describe the tapestries pretty accurately from memory. Astonishingly, however, she states in her very serious article, published in *L'Illustration* on 3 July 1847, that there were eight of them. There is no trace today of two additional tapestries—they are yet another mystery.

Each panel shows the sumptuously dressed woman engaged in a different activity, generally taken to be an allegory of each of the five senses. In the first, for instance, she holds a pennant in one hand and the unicorn's horn in the other (touch), in the second she takes a tidbit from a dish (taste), in the third she plaits a crown of flowers (smell), in the fourth she plays an organ (hearing), and in the fifth she holds a mirror up to the unicorn (sight). But what then does the sixth tapestry mean, which shows the lady, surmounted by the strange inscription "To my only desire," apparently putting a necklace back into a jewelry box? Is it an introduction or a conclusion to the series? Some have suggested that it's an allusion to a sixth sense, that of the heart. Most are agreed that it illustrates a renunciation of the material world, the world of the senses, in favor of the spiritual.

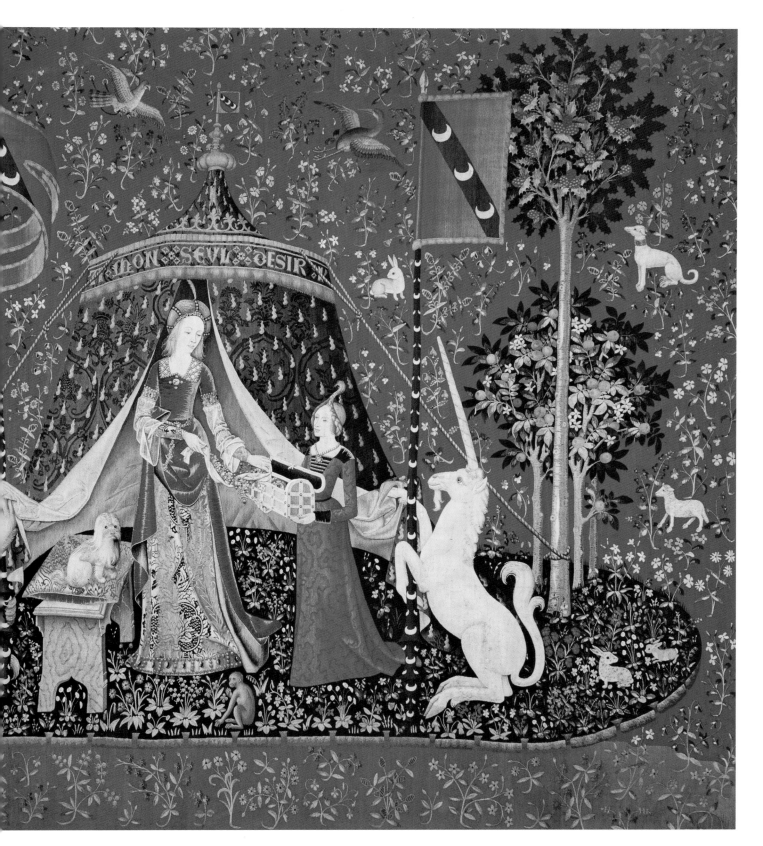

FROM DELIGHT TO DEPRAVITY

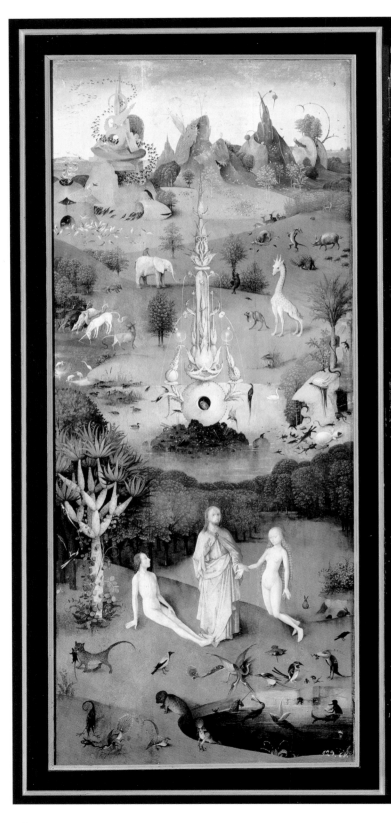
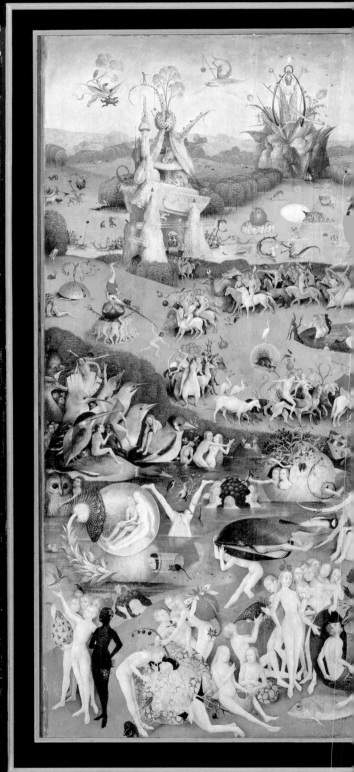

HIERONYMUS VAN AKEN, known as HIERONYMUS BOSCH (C. 1450–1516),
The Garden of Earthly Delights, 1500–1505,
oil on wood, 220 cm × 389 cm, Museo Nacional del Prado, Madrid, Spain

Previous page: *The Garden of Earthly Delights* (outer panels)

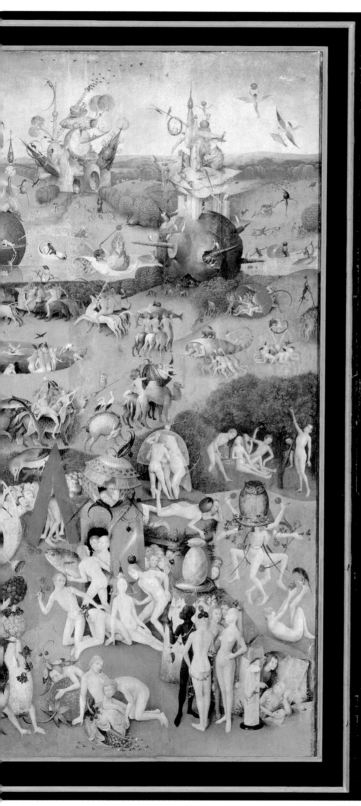

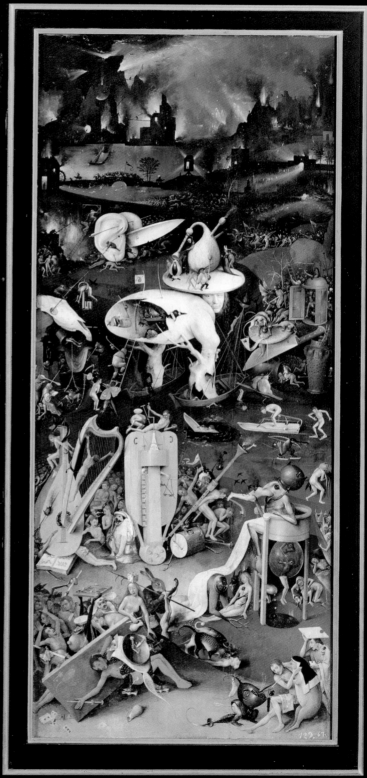

143

Very little is known about Hieronymus Bosch or his work; even attributing paintings to him with any certainty is fraught with difficulty since he did not sign his works and he spawned many imitators. His most famous picture is without doubt *The Garden of Earthly Delights* and it's not difficult to see why: it's a hallucinatory triptych packed with bodies and monstrous, unfamiliar, mythical beings in an incomprehensible setting. What is difficult is to know what it means. There are various theories, but none that we can really be sure of.

Bosch based his paintings closely on the Bible and they always have a moral to impart or a lesson to teach. Although he lived through the Late Middle Ages, he remained largely impervious to the Renaissance, inclining instead towards esotericism and symbolism. There are frequent references in his works to mysterious and occult subjects such as alchemy and astrology, a fact that inevitably contributes to their strangeness and impenetrability, making them difficult to fathom.

The Garden of Earthly Delights is no exception. The scenes it depicts are derived from the Bible, but Bosch's treatment of them is at once erudite and idiosyncratic. Painted on the outside of the panels and visible when the wings of the triptych are closed, is an empty, desolate landscape. From the presence of God and the quotation from Genesis, it would appear that this is the world at the time of the Creation. When it's open, the triptych reads from left to right: the panel on the left conjures up Paradise at the time of the creation of Eve, and the one on the right depicts Hell.

But what of the central panel? It could be an extension of Paradise. Although it features a number of strange forms and beings, including women covered in hair and fantastic creatures, there is no sense of alarm in it. The figures appear at ease, the animals are kindly, nature is bounteous, and nakedness does not seem to be in any way a cause for shame. There is no violence or fear. In fact, the opposite is true: there is physical love in abundance, with couples locked in physical embrace, like the pair in the transparent bubble in the center of the picture or the couples in improbable positions around the fountain of youth in the background.

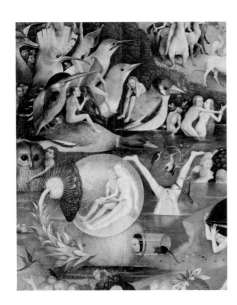 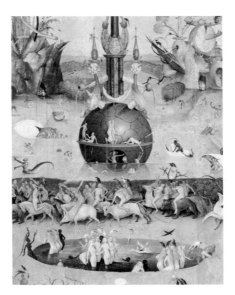 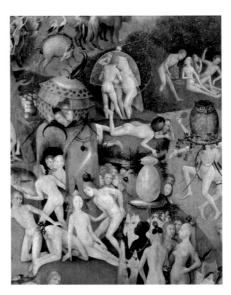

HIERONYMUS VAN AKEN, known as HIERONYMUS BOSCH (C. 1450–1516),
The Garden of Earthly Delights (details), 1500–1505,
oil on wood, 220 cm × 389 cm, Museo Nacional del Prado, Madrid, Spain

With the unicorn, the fountain of youth, and copious quantities of enormous fruit, there is plenty here to warrant the picture being called *The Garden of Earthly Delights*. Bosch's painting is ambiguous and far from straightforward, however, and the scene can be read very differently, as a picture of debauchery and immorality, highlighted by the disturbing presence of fantastic forms and animals. The sin of lust would seem to be its principal theme, and there is something distinctly sensual about those interlocked naked bodies. It could be argued that the panel depicting Paradise and the creation of Eve prepares us for the scene by foreshadowing the introduction of sin into the world by the errant Eve. There are other sins no less in evidence, the argument goes: the figures gorging themselves on huge fruit are clearly guilty of greed and those indolent people sprawled on the ground have obviously succumbed to sloth. Hell is close at hand, and Bosch's painting of it includes a number of subtle and specific tortures used to punish precisely those particular sins.

The truth is that, if the overall meaning is obscure, the individual details are even more so. But do we really need to explain every detail of a painting like this? Is it not enough just to gaze on it and marvel at the extraordinary display of the artist's unbridled imagination it offers us? After all, it was this that earned him his success.

> *The large white face in the center of the Hell panel is often considered to be a self-portrait of Bosch.*

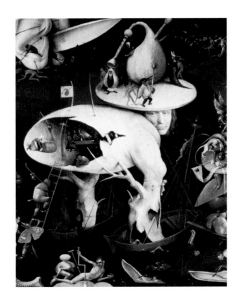
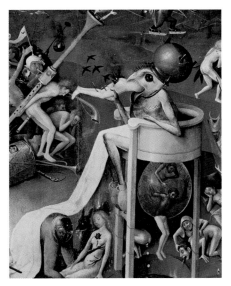
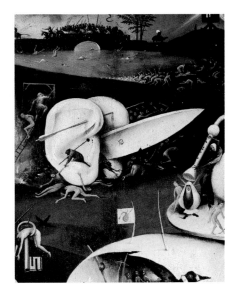

CAUGHT IN A STORM OF INTER- PRETATION

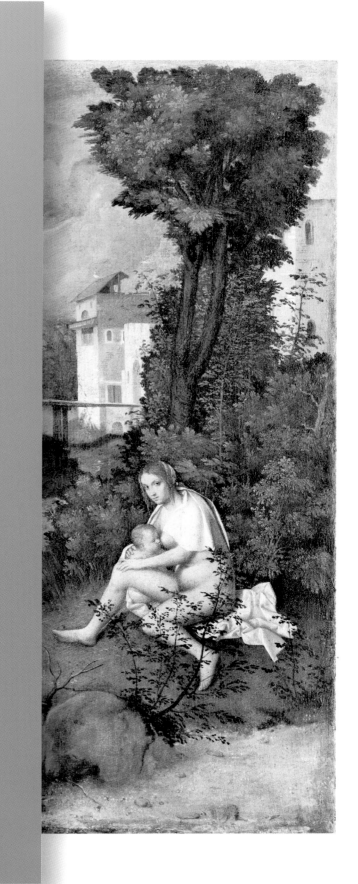

It's almost impossible to make sense of *The Tempest* because it's so full of disparate elements: figures who seem to have nothing to do with one another—a soldier and a naked woman suckling a child sitting not on her lap but on the ground—ruins, a flash of lightning. Many have tried to solve the riddle, however.

The first recorded description we have of the picture comes from Marcantonio Michiel, a Venetian nobleman and connoisseur of art who referred to it as "a little landscape on canvas with a tempest, a gipsy and a soldier" after seeing it on a visit to Gabriele Vendramin's collection in 1530. The picture was probably commissioned by Vendramin, who was an aristocrat and patron of painters in Venice. Did Vendramin encourage his admiring visitor to think of the picture in these terms, or did Michiel come up with them himself because he did not know how else to describe it?

It's certainly difficult to know what Giorgione wants to convey in this picture. A man watches a naked woman, his face half in shadow. He looks like a halberdier from the way he's dressed, but he could equally well be a richly dressed shepherd or perhaps a young nobleman, if the puffed out breeches are anything to go by. X-rays have shown that these are a later addition, however, making it even more difficult to be sure.

The woman looks at us intently, as if she is trying to communicate something. But what? Some people have read her expression as a cry for help in response to the soldier's insistent stare; others have seen it as accusatory, a criticism leveled at viewers for being voyeuristic. X-rays have revealed the existence of another similarly naked female figure by the edge of the water. No one knows at what point or by whom she was painted out. Giorgione may originally have had the woman on the left but changed his mind and moved her over to the right to balance the composition. Other elements in the picture—the stream, the broken columns, the flash of lightning in the background while the sun lights up the foreground—can only be interpreted as obscure symbols.

There have been all sorts of theories about who the figures might be. The wildest, perhaps, is that they are Giorgione and his family, though this is not in fact possible since the painter never married and did not have any children. People have looked to the Bible and mythology or contemporary literature for possible candidates, but no one has yet found a story or source that matches the scene in the picture in its entirety. Another possibility is that the figures are allegorical and that the soldier, for instance, represents Courage, the woman Charity, and the suckling child Chance. Finally, there are some who think that there is no meaning at all to be found, arguing either that Giorgione simply wanted to paint a landscape and that the people are incidental, or that he wanted to create an impossible riddle, an intellectual device then popular in Venice.

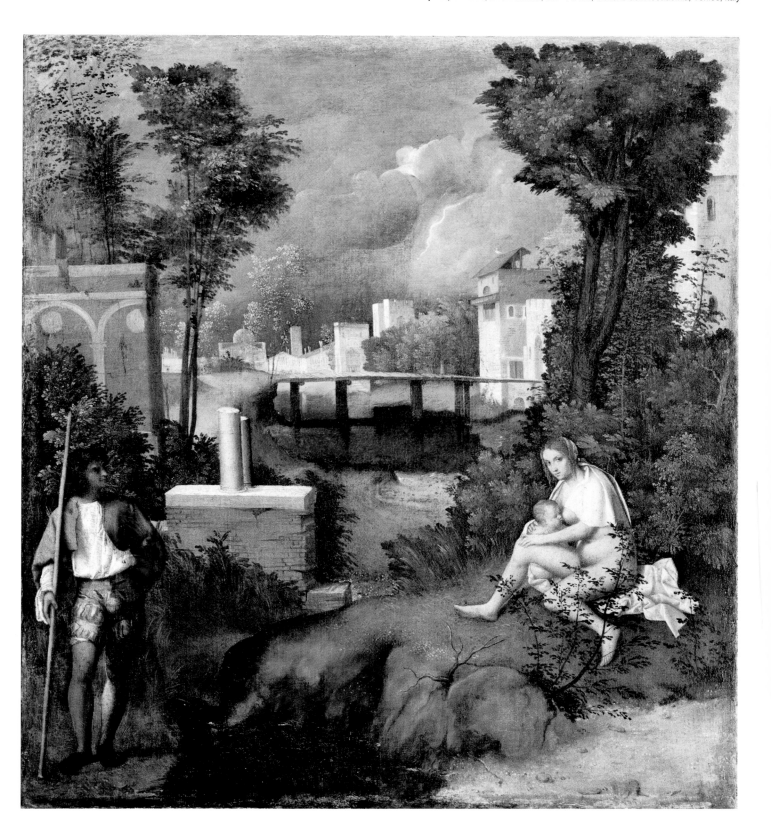

Melencolia I

AT THE LIMITS OF UNDER-STANDING

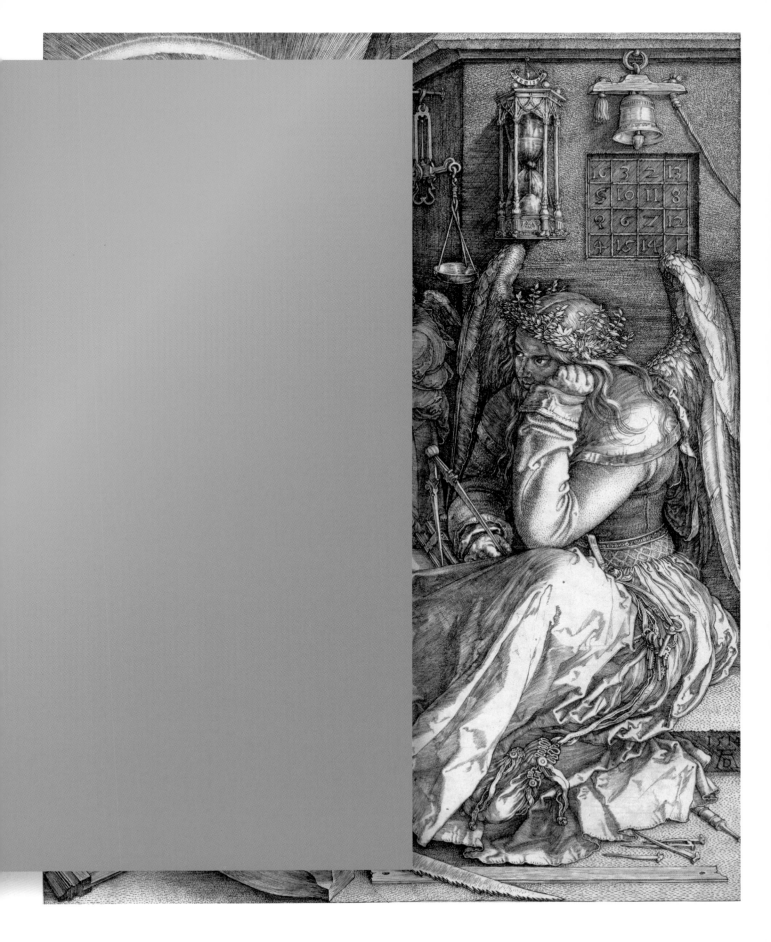

Dürer was an extraordinary all-rounder who was not content to be relegated to the rank of artisan, as artists were in the Middle Ages, but chose to model himself instead on the cultured humanists of the Renaissance. He was not only a painter but also a pioneering printmaker who displayed great technical brilliance and innovation. *Melencholia I* exemplifies his virtuosity as an engraver: in it, subtlety and ingenuity of draftsmanship are matched with a depth of intellectual enquiry so intense that it tends to obscure its meaning.

The engraving packs a host of details into a space no bigger than a sheet of A4, creating an image that is difficult to decipher. The winged and richly dressed figure of Melancholy sits with her head propped heavily on her fist in an attitude that is often used to denote the humor melancholy and makes her easily recognizable. In the top left of the engraving is a bat, another familiar symbol of melancholy because of its attraction to dark places. Its wings are spread wide to display a scroll bearing the inscription "Melencolia I." The "I" is ambiguous: it could be a Roman numeral, suggesting that this is the first in a projected series of engravings on the theme, or a capital "I" and therefore the first letter of a missing and unknown word. The allegorical figure of Melancholy sits on a stone slab in front of a tower. At her feet are ranged a sleeping dog, which almost certainly represents laziness (a fault of which melancholics were often accused), and various tools associated with wood and stone work, which look as if they have been abandoned by their artisan owners. In the background is the sea with a rainbow arching above it and a comet burning through the sky.

Dürer's engraving is based on a neo-Platonic notion of melancholy that saw the humor as a hallmark of genius and in no way harmful, in complete contrast to medieval beliefs. It was a notion that went back to Aristotle, who pointed out in his *Problemata* that every exceptional talent in the arts and politics was a melancholic.

The objects heaped around the figure of Melancholy—a book, an inkwell, a compass, a magic square, a stone polyhedron, an hourglass, and a set of scales—all allude to knowledge. They symbolize learning in general and geometry in particular, then considered to be the mother of all the mathematical arts (to which painting and architecture were also thought to belong). The figure could therefore equally well be construed as an allegory of Geometry, and even of Astronomy (the most noble of the seven liberal arts), traditionally represented with wings.

The art historian Erwin Panofsky saw the figure as an inner self-portrait by Dürer depicting the melancholic state of mind to which his pursuit of perfection and his discovery of the limits of art and science finally led. Dürer famously painted an extraordinary series of portraits of himself over the years, and it would not be surprising if this once he wanted to depict the inner state of his mind rather than the external features of his face.

ALBRECHT DÜRER (1471–1528),
Melencolia I, 1514, engraving, 23.9 × 18.8 cm,
Berlin State Museums, Kupferstichkabinett, Berlin, Germany

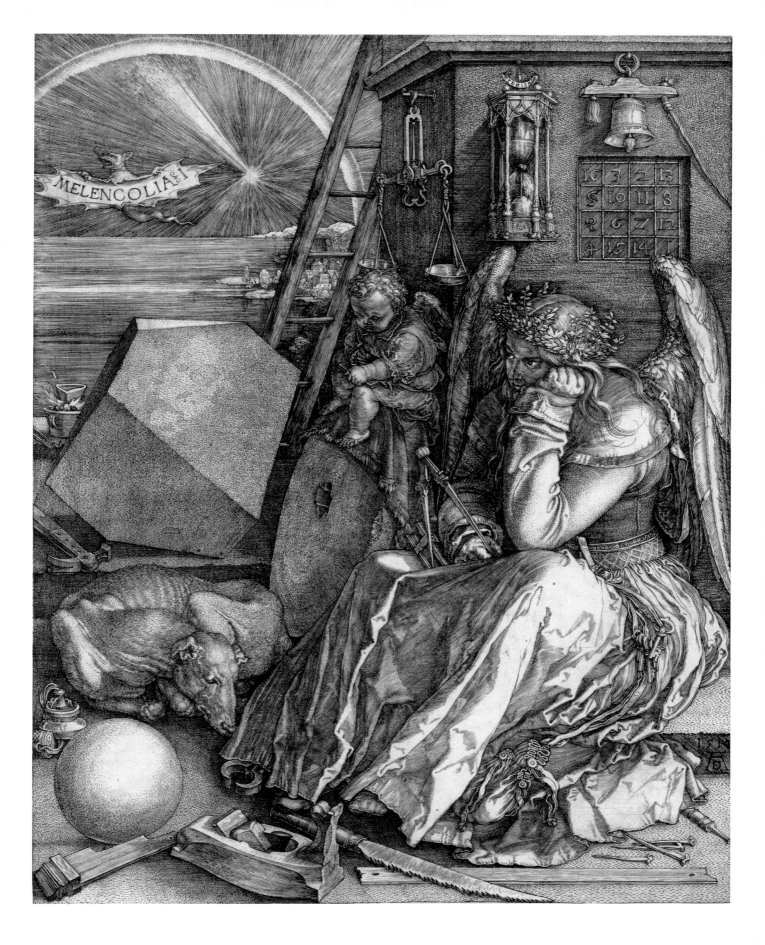

BEWARE, LOVE CAN BE DANGEROUS!

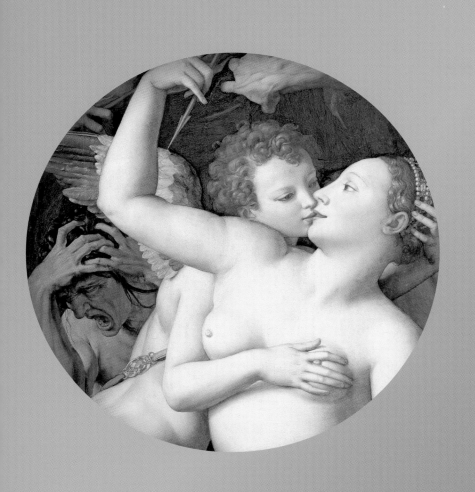

This picture was sent as a present to François I, King of France, by Cosimo de' Medici. It was a diplomatic gift full of things designed to delight the king. François I had a taste for Italian art, enjoyed puzzles, and was famous for his sexual appetite. The picture cleverly gave him a shameless embrace on which to feast his eyes, and also a set of hidden meanings to unravel cunningly woven into it by Bronzino, who was a highly cultured painter and poet.

The picture is distinctly erotic and was intended for the king alone: there is no reference to it in either the royal collections or archives. The composition invites private contemplation, drawing viewers into it as if they were being given privileged access to a hidden scene. The drapes on the ground and in the background remind us that the embrace ought really to have been discreetly curtained off. Two figures hold on firmly to the cloth in the background, the one on the right clearly recognizable as Time from his hourglass, wings, and old man's head. Their actions are ambiguous, doubtless intentionally so, and it's not clear whether they are unveiling the scene or trying to cover it up out of shame or modesty.

It's certainly true that there is considerable sensuality on display here. Cupid is a beautiful young man and he and Venus are both entirely naked. There is no attempt to conceal her genitals or his buttocks and we can see her tongue through her half-open lips as they kiss and as his hand gently holds her erect nipple. However allegorical the meaning may be, we should remember that the two were in fact mother and son in mythology.

The picture is not just a hymn to love, however. It's also a warning against its snares. The young girl with the innocent face, for example, who appears behind the cherub and extends a honeycomb (a symbol of pleasure and the "sweetness" of love) in one hand, seizes a dart with the other and has the body of a monstrous beast. To cap it all, her left and right hands are reversed, as if to emphasize the deceptive nature of love. The theme of deception and the danger of appearances is continued in the two masks on the ground and the one which seems to have come alive in the top left corner. The howling woman on the left can be seen as an allegory of Jealousy or as a personification of Syphilis, the devastating sexually transmitted disease rampant at the time. More subtly still, the cherub treads on thorns that fall from the roses he is carrying and a drop of blood forms on his foot, underlining the thorny snares of love.

Venus, who is shown stealing Cupid's dart, could be interpreted as a classic rendering of Beauty disarming Love. She seems to be aiming it straight at the adolescent's thrust out rear, however. Cupid's quiver projects suggestively below this, and the whole scene could be read as an allusion to sodomy, with Cupid's feminine features and lithe, androgynous body emphasizing the idea of homosexuality.

There seems to be no end to the possible interpretations of this picture, and every figure can be read a number of ways. The right way to look at it is probably to assume that any ambiguity was intentional and that Bronzino wanted there to be multiple meanings.

AGNOLO TORI, known as BRONZINO (1503–1572),
An Allegory with Venus and Cupid, c. 1545,
oil on wood, 146.1 × 116.2 cm, National Gallery, London, United Kingdom

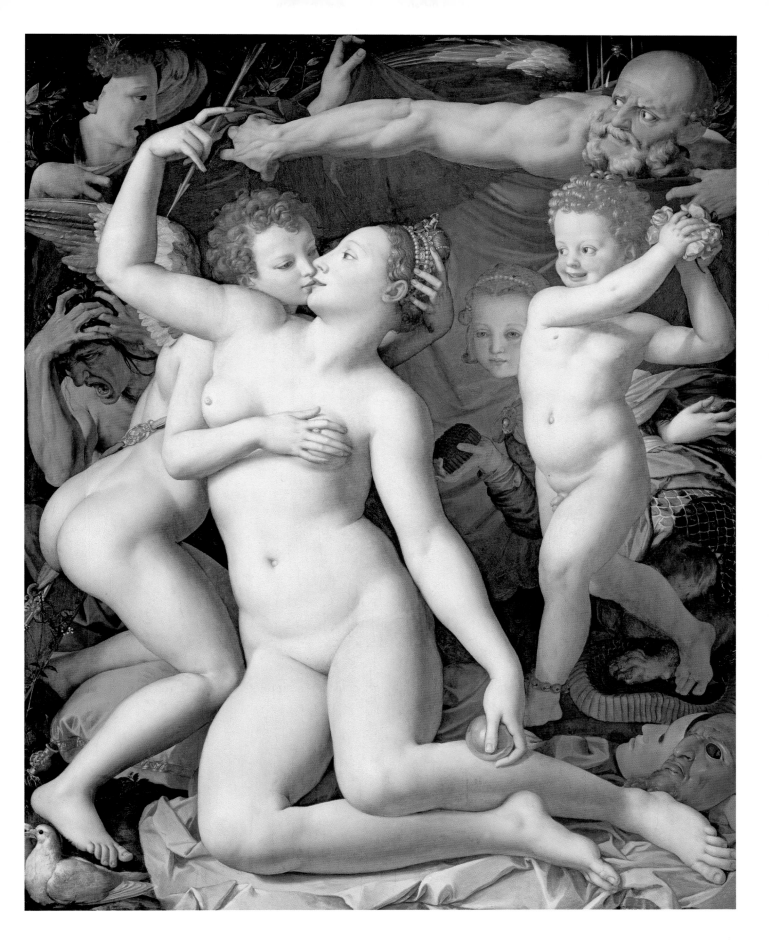

THE WIFE, THE CUCKOLD, AND THE LOVER UNDER THE TABLE

The amorous adventures of Mars and Venus were a common subject in painting, but no other painter treated them quite as Tintoretto did. Tintoretto was widely admired but also criticized for being provocative by reactionary religious figures. In this mischievous painting, he deliberately plants clues that turn a story that is already hardly moral into a farce. Once again it's the mirror that holds the key, this time revealing the ending of the story.

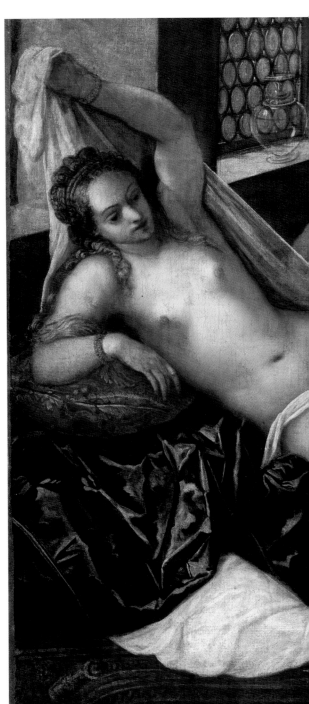

We all know the story of Venus, the magnificent goddess of Love. Forced to marry the ugliest of all the gods, the limping old blacksmith Vulcan, the beautiful goddess was unhappy in her marriage but managed to find solace in the virile arms of Mars, the god of War. One fine day, however, the cuckolded husband surprised the lovers, caught them in a magic net and put them on display, naked and humiliated as they were, for all the other gods to see.

Tintoretto takes up this Greek and Roman myth, but treats in a very individual way: he dispenses with the net and adopts a tone that is unexpected to say the least, more akin to a farce than to a myth. Although he is on the lookout, Vulcan does not see Mars, who for once is probably going to manage to escape. Grotesquely hidden under the table, Mars watches helplessly as the dog barks, obviously hoping that the animal will not give him away. It seems incredible that Vulcan should not be alerted to his presence by the dog's yapping, but as the art historian Daniel Arasse explains, he is so entranced by the sight of his wife that he has completely forgotten his suspicions. As he lifts away the veil covering his wife to find visible proof of her guilt, he becomes transfixed and cannot take his eyes off her. What is going to happen next, we wonder? Will Mars be discovered? Will Vulcan exact his revenge? All will be revealed in the next episode—which is to be found in the mirror.

What we see in the mirror is not a straightforward reflection of the scene taking place. The husband's position is different: he is now on all fours on the bed. In fact, the mirror shows what is about to happen. Having lifted off the veil covering her, Vulcan cannot resist Venus's allure and is about to throw himself on her. We can be pretty sure that he will be too overcome by the charms of the goddess of Love to notice Mars, who will then be able to slip safely away. The scene is both comical and unique: no painter before or since has depicted it in quite this way. It can be read as a criticism of arranged or ill-matched marriages and the unhappiness and excesses they cause, as a warning to men against succumbing to the sexual attraction of women, or quite simply as a bawdy tale that perhaps graced the walls of a Venetian courtesan.

JACOPO ROBUSTI, known as TINTORETTO (1518–1594),
Venus and Mars Surprised by Vulcan, c. 1555,
oil on canvas, 135 × 198 cm, Alte Pinakothek, Munich, Germany

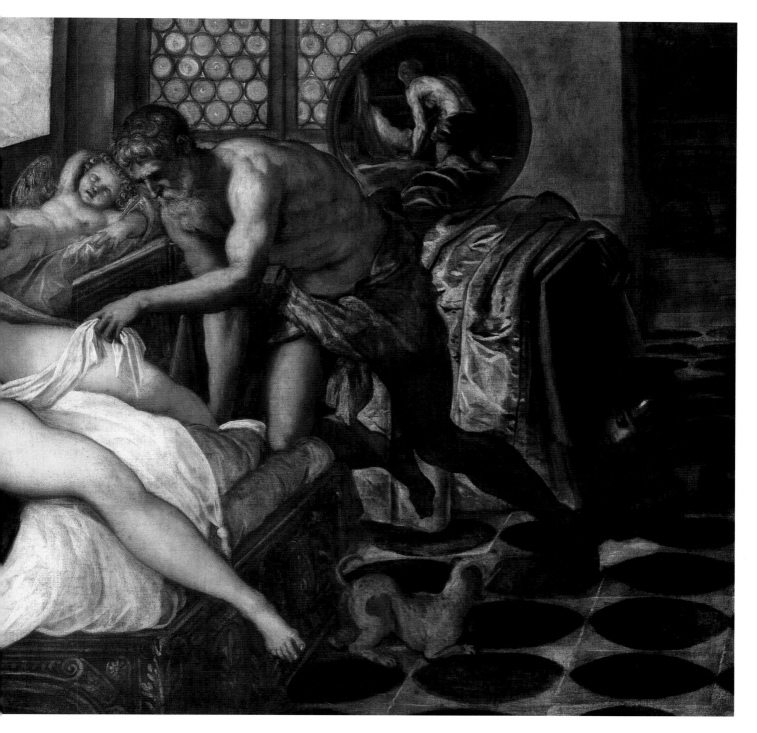

NICOLAS POUSSIN'S HIDDEN TREASURE

In Greek mythology Arcadia was an idyllic place populated by gods and happy shepherds who live in harmony with nature. It continued to be a very popular theme with both painters and poets up until the nineteenth century. When Poussin painted his version of it, he added an obscure Latin inscription which has given rise to countless different inter-pretations.

I t's partly because Poussin painted another picture by the same name some ten years earlier that the famous version of *The Shepherds of Arcadia* now in the Louvre has been so extensively analyzed and discussed. The first painting shows four shepherds trying to decipher a phrase inscribed on a tomb. Poussin repeated the scene in the later, better known version, but with notable changes. The same figures are present but they are no longer seen from behind. Rather than appearing alarmed by their discovery, they seem to be thinking about what to make of the tomb. The inscription is not immediately apparent in this painting: instead, the shepherds, the tomb and the setting take center stage. There is something more tranquil about the second setting: the words are set in a carefully constructed and considered landscape. Why did Poussin make all these changes? How are we to approach the scene? The shepherdess on the right shows us the way: unlike the first picture, this one calls for us to engage actively rather than to look on as detached observers, and to think about the inscription just as she is doing.

There is general agreement among scholars today that the meaning of the inscription on the tomb, "Et in Arcadia Ego," is "Even in Arcadia I (Death) Exist." The implication is that even in Arcadia, that radiant country populated by nymphs and blessed shepherds, death is omnipresent and human happiness therefore inevitably ephemeral and vain. Poussin is reminding us that death is inescapable.

Yet is this painting perhaps more than a *memento mori*? Researchers and enthusiasts have been quick to ascribe all kinds of meaning to the picture and to construct countless elaborate theories about it. As the saying goes, "he who seeks shall find," and some commentators are convinced that *The Shepherds of Arcadia* is the key to the mystery of Rennes-le-Château. In the early twentieth century, the abbot of Rennes-le-Château, Bérenger Saunière, suddenly became rich and rumor had it that he had found and subsequently concealed a treasure. Saunière is known to have bought a copy of the Louvre painting and it was immediately inferred from this that there was a connection between the supposed treasure and Poussin's painting. The writer Ollivier Ruca has very recently gone further still, asserting that the painting is like a map and that the landscape in this pastoral scene is precisely based on the view Poussin could see from the Château of Puivert, in the Aude. François Bérenger Saunière's treasure has yet to be discovered. In the meantime, there is a steady supply of Poussin researchers eager to find hidden meanings in the picture, from trompe-l'oeil constellations in the silhouettes of the figures, to hidden masonic symbols and signs indicating that the tomb is meant to be that of Christ. None of these theories has found universal support, however, leaving one to wonder if perhaps the only mystery Poussin wanted to make us see clearly was that of death.

NICOLAS POUSSIN (1594–1665),
The Shepherds of Arcadia, also known as **Et in Arcadia Ego,** c. 1638–1640,
oil on canvas, 85 × 121 cm, Musée du Louvre,
Paris, France

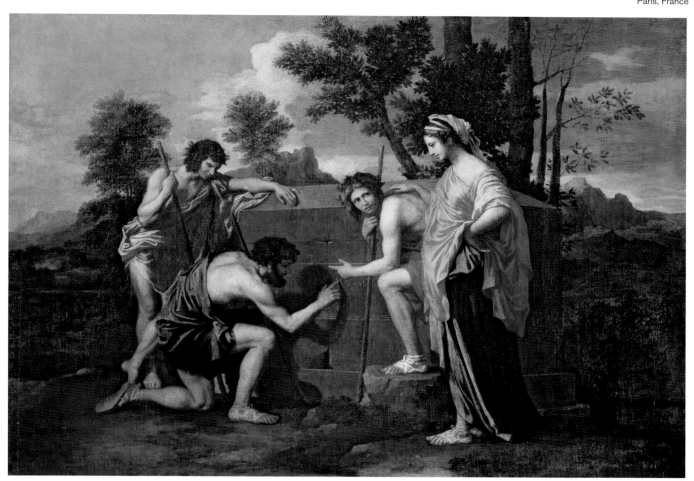

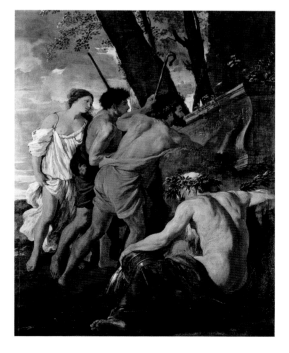

NICOLAS POUSSIN (1594–1665),
The Shepherds of Arcadia, c. 1628–1630,
oil on canvas, 101 × 82 cm, private collection,
Chatsworth House,
Derbyshire, United Kingdom

THE RIDDLE OF THE SPHINX

Fernand Khnopff was a leading figure in the Symbolist movement, and mystery, dreams and heightened emotions feature largely in his work. His best-known painting is also his most impenetrable and includes a sphinx that is not quite a sphinx, mysterious inscriptions, and an androgynous figure who could be Oedipus or the painter himself.

The Caress depicts a cheetah with the head of a woman, a figure reminiscent of the Sphinx in Greek mythology, resting her cheek against that of a young man who holds a scepter in his right hand. Her eyes are closed and she wears an expression of intense pleasure on her face. At first glance, this looks like a scene from the myth of Oedipus. If it's the scene in which Oedipus attempts to solve the riddle of the Sphinx, however, as the antique columns in the background would tend to suggest, then

Khnopff gives it an entirely new twist. First of all, the female sphinx looks nothing like the one in the myth, which has the body of a lion and the wings of a bird and confronts Oedipus with a riddle. Second, and utterly contrary to all that we might expect, there is no confrontation of any kind in the picture: the Sphinx is not challenging Oedipus to answer her famous question ("What walks on four legs in the morning, two at midday and three in the evening?") and the hero is not throwing his answer ("Man") back at her. In fact it's quite the

opposite: far from confronting one another, they seem to be very much together in what is a very unusual take on the myth, and one freighted with intense but obscure desire. The idea of the two being one is reflected in the classical-seeming landscape, with the two linked columns in the background symbolizing union. If this is indeed Khnopff's theme, why did he choose to explore it by depicting a well-known episode in mythology in which there is absolutely no mention of union or romantic involvement?

Khnopff is thought in fact to have based his painting on a short story by Honoré de Balzac written in 1830 and entitled *A Passion in the Desert*, which features the astonishing love affair between a soldier and a panther. Even this leaves a good many aspects of the painting unexplained, however. Why, for example, is there such a striking facial resemblance between the figure we take to be Oedipus and Khnopff himself, bearing in mind that it was based not on himself, but on his beloved sister Marguerite, as indeed the figure of the Sphinx was too? One suggestion is that the androgynous half-Fernand half-Marguerite figure was Khnopff's way of channeling his repressed incestuous feelings. There is some weight to this, particularly when we remember that Oedipus was famously capable of committing incest, albeit unwittingly. Other aspects of the painting remain obscure. We do not know what to make of the strange temple with its illegible inscriptions that blocks out the landscape in the center of the painting of the painting, for instance, or of the scepter topped with a winged sphinx dominating the globe, and Khnopff never explained why he included these.

Whatever its meaning, *The Caress* heralded a fundamental change in the painter's work: his paintings were to become increasingly voluptuous thereafter and the mysterious and erstwhile ethereal women in them ever more sensual and enticing.

JOURNEY TO THE CENTER OF ROUSSEAU'S SUBCONSCIOUS

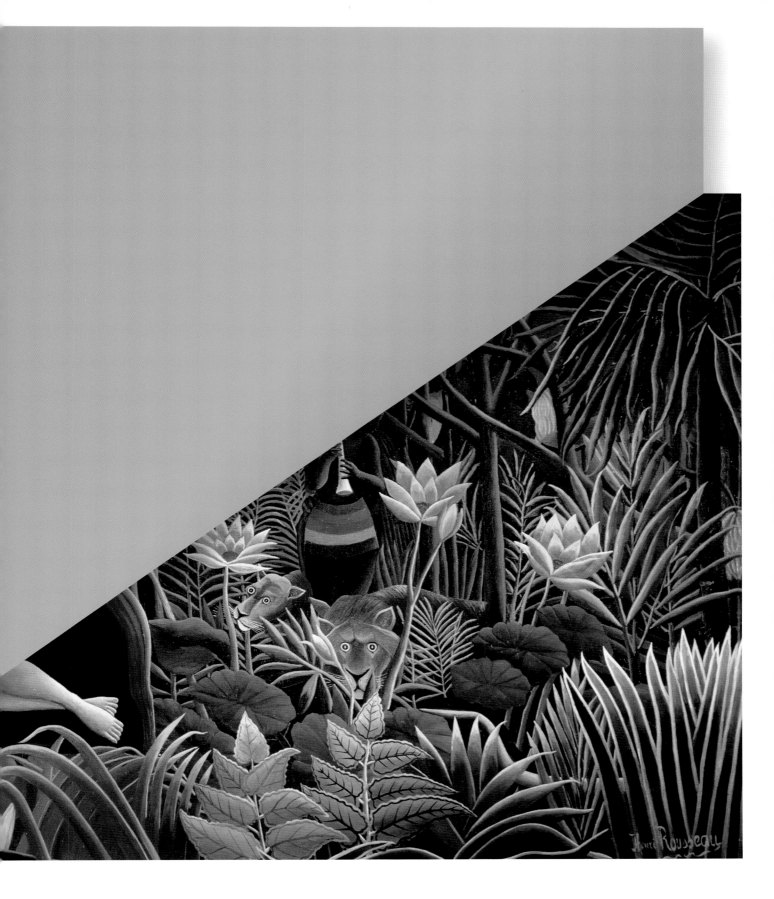

Henri Rousseau was a self-taught painter. Nicknamed Le Douanier Rousseau ("the Toll Collector") because of his job, he produced some twenty pictures of jungles in the course of his career, culminating in *The Dream*, the largest and most complex of them all. Where did he get his inspiration for this extraordinarily luxuriant landscape with its wild animals, an unknown native and a naked woman reclining on a sofa, and what do they all mean?

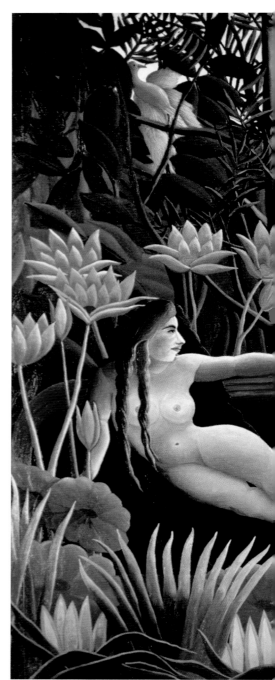

To have been able to paint a landscape like this, Rousseau must have traveled to distant and unknown tropical lands. This is certainly what he tried to get people to believe, telling them that he had been inspired by the rainforest of Mexico, which he got to see when he was posted there with his regiment to support Maximilian of Austria in his ill-fated attempt to become Emperor of Mexico. In fact, we now know that this was all a myth and that the humble government official never left France. When he was not immersed in books of photographs or travelers' tales, Rousseau spent his time in the Jardin des Plantes and the Musée d'Histoire Naturelle studying exotic plants and wild wild animals, though it was an engraving he came across in a popular magazine that provided the basis for *The Dream*.

What does the picture mean? Rousseau did his best to give viewers a few clues. He decided to emulate the practice adopted by many academic painters of getting their poet friends to compose a few lines to accompany their pictures. When the picture was exhibited at the Salon des Indépendants in the spring of 1910, he set next to it the following lines of his own devising: "Yadwigha in a beautiful dream / Having fallen sweetly asleep, / Heard the strains of an accordion / Played by a god-fearing charmer. […]"

If these lines are to be believed, the picture depicts Yadwigha in the act of dreaming. This would certainly explain all the incongruous elements and the strange setting. But who is Yadwigha? Was she a real person? According to some of Rousseau's friends, such as the poet Guillaume Apollinaire and Pablo Picasso, she may have been a youthful love of the painter's, of Polish origin. The name also figures in a play written by Henri Rousseau in 1899. Apart from this, however, there is no evidence to suggest that the young woman ever existed, and it may well be that she is no more than a figment of the painter's imagination, conjured up to lend exotic color to his life, just like his fictitious voyage to Mexico. Her existence is further thrown into doubt by the fact that she bears little resemblance to the other young woman identified as Yadwigha, who supposedly served as a model for his *Portrait of a Woman* (1895, Musée Picasso, Paris), which he painted fifteen years before he depicted here but the inexplicable products of his subconscious.

What is Rousseau trying to convey in this imaginary scene? Perhaps it's not Yadwigha's dream but his own, allowing himself to be guided by his unconscious and giving visual form to the desires and fears which trouble him.

HENRI ROUSSEAU, known as LE DOUANIER ROUSSEAU (1844–1910),
The Dream, 1910,
oil on canvas, 204.5 × 298.5 cm, Museum of Modern Art, New York, United States

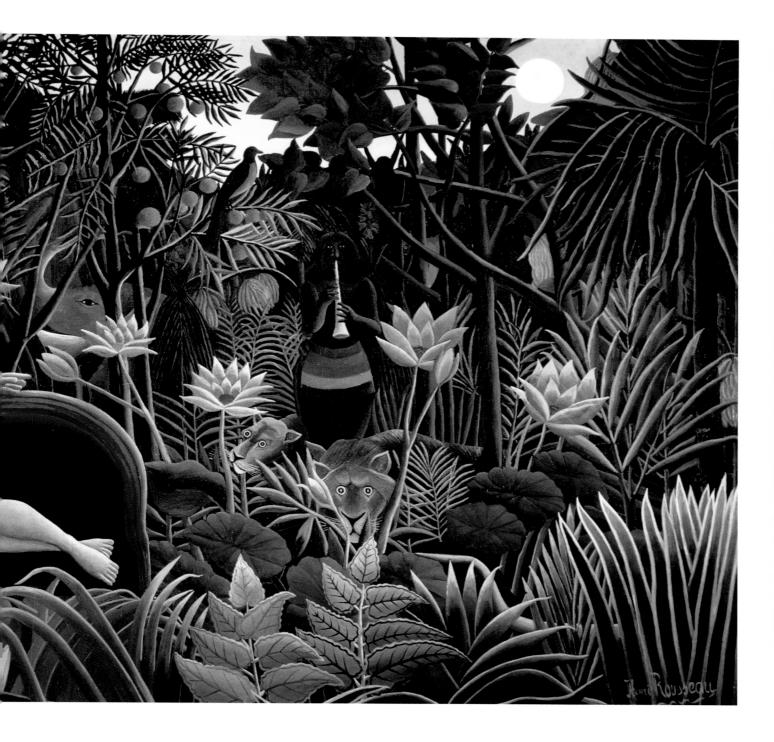

Index of Artists

Picture Credits